LINES OF VISION

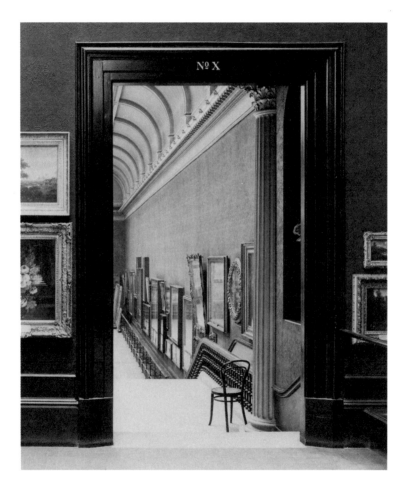

Interior view, National Gallery of Ireland, *c.* 1929

LINES OF VISION

Irish Writers on Art

Edited by Janet McLean

With 60 illustrations

First published in the United Kingdom in 2014
by Thames & Hudson Ltd, 181A High Holborn, London WC1V 7QX

British Library Cataloguing-in-Publication Data
A catalogue record for this book is available
from the British Library

ISBN 978-0-500-51756-7

Printed and bound in China by C & C Offset Printing Co. Ltd

To find out about all our publications, please visit
www.thamesandhudson.com. There you can subscribe to
our e-newsletter, browse or download our current catalogue,
and buy any titles that are in print.

CONTENTS

FOREWORD

The National Gallery of Ireland opened its doors to the public for the first time in 1864. It then displayed 112 paintings. Today the collection has grown to comprise over 15,000 works of art, dating from the thirteenth century to the present day. To mark the 150th anniversary of the gallery, fifty-six Irish writers have contributed essays, stories and poems to *Lines of Vision*, an anthology inspired by its rich collection. Their texts span a wide range of genres to give unique perspectives into the pictures they have chosen.

The writers have selected diverse works from across the collection. They include treasured paintings by masters such as Caravaggio, Rembrandt, Vermeer, Poussin and Velázquez; works by Irish artists such as Jack B. Yeats, John Lavery and Paul Henry; and modern European pictures by Claude Monet, Pierre Bonnard and Gabriele Münter. This creative collaboration invites us to look at the National Gallery of Ireland and its wonderful collection in new and intriguing ways.

SEAN RAINBIRD, DIRECTOR, NATIONAL GALLERY OF IRELAND

PREFACE

When the National Gallery of Ireland opened on 30 January 1864, among the guests gathered for the official ceremony was the newly knighted Sir William Wilde. While it might be considered fanciful to imagine that his nine-year-old son, Oscar, watched the grand occasion from the windows of their family home on Merrion Square, what cannot be doubted is that, from that day forward, the National Gallery has come to figure prominently in Irish literary life.

George Bernard Shaw had been living in England for almost seventy years when, in 1944, he wrote to Thomas Bodkin, a former director, saying that he owed the gallery 'much of the only real education I ever got as a boy in Eire.' He subsequently bequeathed one third of the royalties from his work to fund new acquisitions. These have included Roderic O'Conor's *La Jeune Bretonne* and Jack B. Yeats's *Grief*, paintings which have in turn, inspired the contributions of Dermot Bolger and Carlo Gébler in this volume. W. B. Yeats belonged to a family of artists and studied at Dublin's Metropolitan School of Art before embarking on the path of poetry. He remained interested in art throughout his life and joined the gallery's Board of Governors in the 1920s. Paintings by his father, John, and brother, Jack, are included in this book.

The writer and poet James Stephens was the gallery registrar from 1919 to 1924. During this period he published several books, including the popular *Irish Fairy Tales* (1920), illustrated by Arthur Rackham. Stephens's successor, Brinsley MacNamara, took up the post having been exiled from his hometown in Co. Westmeath where his novel *Valley of the Squinting Windows* (1918) had been received with hostility. He continued to write fiction and plays

4, WHITEHALL COURT (130) LONDON, S.W.I.

TELEGRAMS: SOCIALIST, PARL-LONDON.

TELEPHONE: WHITEHALL 3160.

AYOT ST LAWRENCE, WELWYN, HERTS.

STATION: WHEATHAMPSTEAD, L & N.E.R., 2¼ MILES.

TELEGRAMS AND PHONE: CODICOTE 218.

7/3/1944

From Bernard Shaw.

Do you remember our meeting at Plunketts, years ago? If so, may I ask you a question?

I am making a will leaving my Irish property for certain public purposes which may prove impracticable. In that case it is to go to the National Gallery (your old shop), to which I owe much of the only real education I ever got as a boy in Éire.

What I want to know is —

Is there any special fund for the purchase of pictures as distinct from general establishment charges? If so, I should be inclined to earmark my bequest for it. Would you do so if you were in my place?

G. Bernard Shaw

I have become somewhat familiar with Birmingham through Sir Barry Jackson and his Repertory Theatre.

Postcard from George Bernard Shaw
to Thomas Bodkin, 7 March 1944

up until his retirement in 1960. The respected poet and critic Thomas MacGreevy was the gallery's director from 1950 to 1963. Samuel Beckett, an old friend of MacGreevy, had come to know the gallery as a young man and was particularly keen on its early Italian paintings and works by Dutch and Flemish Masters. It was MacGreevy who introduced Beckett to Jack B. Yeats, an artist whose work they both deeply admired and which continues to resonate with writers today.

Lines of Vision brings together new work by Irish writers, inspired by the National Gallery of Ireland and its collection. Contributors were invited to select pictures as setting-off points for poems, stories and essays. Each has embraced the undertaking with unfailing enthusiasm and tremendous generosity of spirit.

Behind the scenes, the picture selection process was a delightfully idiosyncratic one. A number of writers visited the gallery with an idea but not a picture in mind, others perused its stores, a few gave approval to prompted pairings, while most chose works of art that they had long loved and even lived with as postcards propped on mantelpieces or tacked to study walls. The writers' reasons for choosing pictures are as diverse as those they chose. Pictures have been used as stimuli for dormant stories waiting to be told. Pictures have teased out long-held observations and nudged them into form and focus. Pictures have become the fabric on which remembrances have been pinned like precious brooches. Pictures have been reimagined, their details magnified and presented in new lights.

For many years the National Gallery was one of the few secular spaces where art could be seen in Ireland. Indeed it is quite possible that for many of the writers in this book, their initial encounters with art were with religious imagery seen in churches and schools; altarpieces, stained-glass windows, shrines, Stations of the Cross, Sacred Heart prints. The interweaving of art, poetry, stories and spirituality comes almost as second-nature to Irish writers. While it is perhaps unsurprising that many find an affinity with religious scenes and subject matter, it is certainly intriguing that several

have been drawn to images of ascetic saints. St Mary Magdalene, St Jerome, St Francis and St Onuphrius – their pictured lives of austere and contemplative solitude bear distinct parallels with the garret-occupation of writing.

Galleries are places where few questions are asked or expectations are made. Quite often they are places of retreat for those who have time to pass or places of refuge for those who feel they don't fit in. The idea of art as a bolthole from uncomfortable realities – in childhood, adolescence and adulthood – is a reassuring and recurrent one in this collection of writing. Galleries invite their visitors to engage in discreet acts of intimacy. There is a silence and a stillness implied in looking at art. Writers are perhaps more at ease with the practice of seeing slowly than most.

Many writers have found in paintings fragile bridges by which to bring lost loved ones closer into view. Sebastian Barry movingly remembers his artist grandfather; Bernard Farrell and Martin Malone the quiet dignity of their fathers; Eiléan Ní Chuilleanáin her sister, a violinist; Michael Longley his friend Gerard Dillon; and Jennifer Johnston her hospitable godmother. Quite remarkably, Eva Bourke reflects upon a portrait of her ancestor, Anton Hundertpfundt, Master of the Mint to the Bavarian court in the sixteenth century.

Pictures in public collections might be looked upon as meeting points. They hang suspended on their fixings while people pause, and then, like time, pass by. When looking at pictures we see what others saw before us and what others after us will see. There is a poignant beauty to be found in these invisible path-crossings. Shortly after visiting the National Gallery of Ireland in 1926, Louis MacNeice wrote 'Poussin' inspired by the painting *Acis and Galatea* (1627–28).[1]

A decade or so later, W. B. Yeats alluded to that same painting in one of his final poems 'News for the Delphic Oracle' (1939). MacNeice, barely in his twenties, saw possibilities, while Yeats, in his seventies, saw frustrations and frailties reflected. For this book John

LOUIS MacNEICE

Poussin

In that Poussin the clouds are like golden tea,
And underneath the limbs flow rhythmically,
The cupids' blue feathers beat musically,
And we dally and dip our spoon in the golden tea.
The tea flows down the steps and up again,
An old-world fountain, pouring from sculptured lips,
And the chilly marble drop like sugar slips
And is lost in the dark gold depths, and the refrain
Of tea-leaves floats about and in and out,
And the motion is still as when one walks and the moon
Walks parallel but relations remain the same.
And thus we never reach the dregs of the cup,
Though we drink it up and drink it up and drink it up,
And thus we dally and dip our spoon.

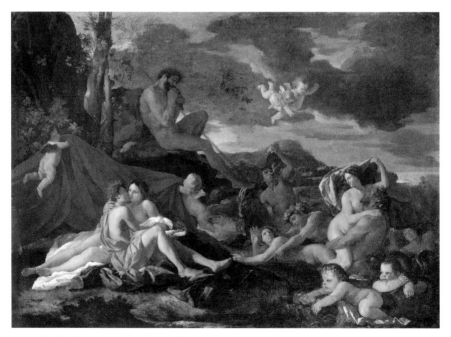

Nicolas Poussin, 1594–1665, *Acis and Galatea*, 1627–28, oil on canvas, 98 × 137 cm

Montague has revisited El Greco's *St Francis Receiving the Stigmata* and a poem that he wrote with it in mind in 1953. The painting is his meeting point, regarded anew after fifty years.

Returning to MacNeice, who deftly compares Poussin's painted clouds to 'golden tea', in many respects his poem prefigures the premise behind this collection of writing. MacNeice brings together the past and the present, the real and the imagined, the arcane and the familiar in exquisite harmony. A picture in a gallery may seem constant and unchanging, yet no matter how frequently we 'dally and dip' into it, we will never reach the bottom. The profound, playful and insightful responses to art in *Lines of Vision* reveal this to be a very good thing.

JANET McLEAN, CURATOR OF EUROPEAN ART 1850−1950

[1] Poussin's painting was known as *The Marriage of Thetis and Peleus* until 1960.

CHRIS AGEE

I remember those days

in The Hague
moving through the Mauritshuis
with its stanzas
of Vermeer-space
suggesting the sense
of love thwarted
or endangered
but enduring
during
the Dutch Wars

then taking
the tramlines
straight and shining
over grassy sleepers
in lush May
through Scheveningen's woods
to *World Forum Noord*
and the Tribunal's
Dantesque circles
at *Churchillplein*

Blown along

the bike-track
drifts of fluttering
heart-shaped beige catkins
like legions
of the lost
thronging

and imploring
the gates
of the living
Tribunal

And so up until now
the only always
here-and-now
Miriam and the Moses basket
the art
of Pharaoh's daughter
in the poet's eye
out of the coeval I
pushing forth love's basket
of bulrush and bitumen

from receding planes
into
the past presence
of the invisible foreground
of receiving us

the Mauritshuis: the Royal Picture Gallery, containing many paintings by Vermeer and other artists of the Dutch Golden Age.

the Dutch Wars: a series of destructive conflicts between the English, Dutch and French (1652–78), involving both sea and land battles, and rooted in commercial rivalry.

the Tribunal: the International Criminal Tribunal for the Former Yugoslavia, The Hague.

Miriam and the Moses basket: the Biblical story in the background painting.

Johannes Vermeer, 1632–1675
Woman Writing a Letter, with her Maid, c. 1670
Oil on canvas, 71.1 × 60.5 cm

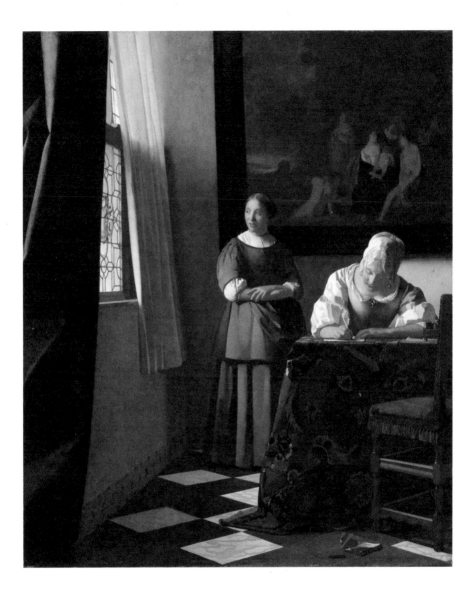

Caravaggio's *The Taking of Christ*

Nah sind wir, Herr,
nahe und greifbar.

Gegriffen schon, Herr,
ineinander verkrallt, als wär
der Leib eines jeden von uns
dein Leib, Herr.

Bete, Herr,
bete zu uns,
wir sind nah.

Near are we, Lord,
Near and graspable.

Grasped already, Lord,
clawed into each other, as if
each of our bodies were
your body, Lord.

Pray, Lord,
pray to us,
we are near.

from 'Tenebrae' by Paul Celan, *Selected Poems and Prose of Paul Celan*, translated by John Felstiner (W. W. Norton, New York, 2001).

Caravaggio is the painter of night, although his is a densely peopled darkness. Even in his daytime pictures the atmosphere is occluded, nocturnal. He is one of the great colourists, yet his tones are muted – at once muted and vivid – and his favourite, his fundamental, his primordial shade is that opulent, luminous pitch-black from which his scenes start out at us as if a light had just been switched on which in a moment will be just as abruptly extinguished. His pictures are monumental glimpses, and before them we do not know whether we are to be captivated or appalled. There is violence in these paintings, violence, menace and mephitic laughter, as well as captivating beauty.

The painter himself comes to us out of a rich chiaroscuro. Michelangelo Merisi da Caravaggio was not a nice man. What was said of Byron could be as well said of him, that he was mad, bad and dangerous to know. Born in 1571, he was dead by the age of thirty-eight, from fever, it seems, though he may have been murdered. If it was murder, it is hardly surprising, for he had lived by the sword. Indeed, he killed a man himself, in the spring of 1606, when in Rome he knifed to death a young Umbrian, one Ranuccio Tomassoni.

Throughout his brief life Caravaggio was a swaggerer and a brawler, a pederast, an adept with the stiletto on whom the police had a record that ran to many pages; he was also one of the most famous and acclaimed painters of his day, and one of the greatest artists. At his death his reputation languished with him, and was not revived until, early in the twentieth century, the critic Roberto Longhi and the connoisseur Bernard Berenson identified him as not only a supreme artist but also as a pivotal figure in the development of painting. As Longhi said, without Caravaggio there would have been no Rembrandt or Vermeer, and the work of Delacroix and Manet would have been very different from what it was.

In describing *The Taking of Christ* one searches for some other, better word than dramatic – incandescent, perhaps, would do, though even that is not quite fiery enough. When we first enter the gallery and catch sight of the painting we have the impression

JOHN BANVILLE

Caravaggio (Michelangelo Merisi), (1571–1610)
The Taking of Christ, 1602
Oil on canvas, 133.5 × 169.5 cm

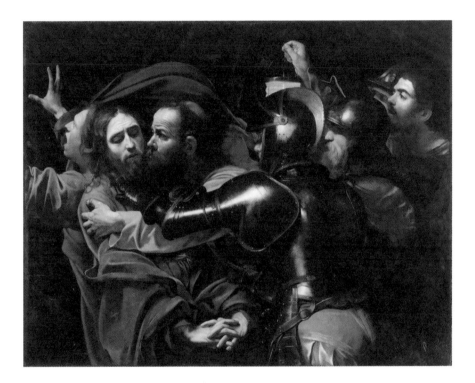

of a violent swirl of action surging forward out of deepest night. An arc of tenebrous light runs from the illuminated forehead of the figure on the right, who holds a lantern aloft – it is a self-portrait of Caravaggio – to the upflung hand of the terrified St John at the extreme left. Approaching a little closer, we make out the fuller composition, which is an inverted triangle with its apex at the oddly clasped hands of Christ. However, this triangular form, which encloses the essential action of the picture, is pushed a little way into the background by the helmeted soldier's extraordinary armoured arm, bulbous, gleaming, blue-black, that seems almost a piece of weaponry, a giant buckler or metal club, thrusting itself to our attention.

In lyric contrast to the mass and iron denseness of this *homme armé* are the lovely flying curve of St John's red cloak as it is seized from behind by the third, barely glimpsed soldier on the right, and the folds of the blue cloak, that might be by El Greco, draped over Christ's downwardly extended arms. We note too how the five figures to the right of the composition, even the mostly hidden soldier at the back, are each distinct, an individual being inhabiting an individual space, while Jesus and St John seem almost fused together at the backs of their heads, like conjoined twins.

The scene is exclusively masculine, not only by virtue of the fact that all the figures in it are men. Caravaggio, as we see throughout his work, and certainly in those paintings of his maturity, was possessed by an almost ravening sensuality; for him the erotic, and in particular the homoerotic, is a source of kinetic energy, a passionate and overwhelming force. Even here, in this moment of religious terror and tragedy, a covert sexuality is at play – if play is the word. Look at the expression he gives himself in his own self-portrait: it displays the swollen, slack-lipped, slightly dazed eagerness of the voyeur who cannot believe his luck in stumbling – with a lantern! – on a scene in which a trio of forceful, irresistible men are seizing violently upon their almost voluptuously suffering victim.

What, indeed, are we to make of Christ's pose here? From the way his hands are clasped we understand that a moment before they were joined in prayer, and that he has lowered them under the weight of Judas's fumbling embrace. In his expression we see clearly his foreboding sense of the agonies that are to come next day, and we fear for him and pity him; yet in his stance there is, too, something disturbingly reminiscent of one of Burne-Jones's Pre-Raphaelite maidens delicately shrinking from the advances of a band of importunate and rapacious knights.

And while we are in the realm of the senses and the sensual, look at the foreground soldier's outthrust rump, as solid as a horse's haunch, belted and buckled and yet garlanded with a band of golden satin: here, in this seemingly casual detail, the covert erotic intent of the painting finds its sly triumph.

Yet all this dark playfulness is subordinate to the pathos and power of what is surely the central figure in the composition. It is on Judas that the narrative weight of the pictures rests. He is, unlike the divine and passive Christ, a wholly human creature, clumsy, desperate, driven. In his face we see a tormented awareness of the enormity of the betrayal he is perpetrating, and in his left hand, awkwardly grasping at the ultimately ungraspable God, we are reminded that the humble and lowly ones are as capable of wickedness as a strutting aristocrat, a rampaging *condottiere*, or a master painter. Who else but Caravaggio would have had the genius, the daring or the compassion to paint such a mundane yet tragic figure?

The Romantics conceived of the sublime as that which overawes and terrifies. In this sense of the word – indeed, in any sense of it – Caravaggio is a sublime painter, and in *The Taking of Christ* he reaches the pinnacle of sublimity, and plunges, too, into the deepest depths.

ALEX BARCLAY

Determination

O ur time together is often recreated, its tincture surfacing like the dome of blood after a needle's withdrawal; not altogether surprising, just bright, noticeable and needing to be wiped away before anyone sees it. Before it stains.

I might find myself walking a hallway and believing it will take me somewhere entirely different, that a door will open into a room where my beloved sits, as always. Why wouldn't he, if it's 6.30 a.m. and my coffee mug and the air smell the same, and the timber floor is warm under my bare feet, just like that time…

Of course, these recreations are strange collusions between restless memories and the choices I make as I set my alarm and take down the dove-grey mug and fill it with that blend and leave my shoes where they landed by the bed.

There is only one mirror in my house, a hand mirror in a drawer. Otherwise, on these walks, I might catch sight of the older me, and the illusion is shattered, and I believe, by some misunderstanding of the process, that it will bring me seven more years of bad luck.

Remarkably, in all this time, I have been powered by that small red remnant core in the clouded blackness. I cannot determine, between them, which one is the growth.

For this is the landscape of my heart. And into its chambers, never was a slower needle driven.

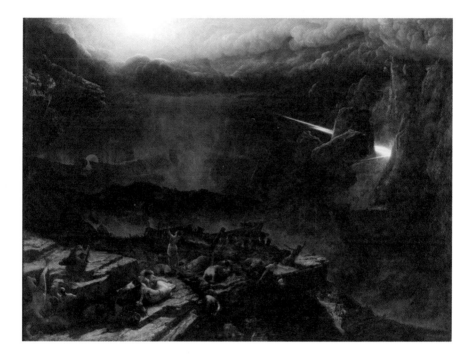

Francis Danby, 1793–1861
The Opening of the Sixth Seal, 1828
Oil on canvas, 185 × 255 cm

Ernest Procter, 1886–1935
The Devil's Disc, c. 1928
Oil on canvas, 30 × 46 cm

KEVIN BARRY

On the Devil's Disc

I met her on the last night of the fair. She smelled of stale and lanes. She said her name was Greta. It looked like it might rain or it might hold off a while – it was one of those nights you wouldn't know which way it would go.

I said, how are ya, girl?

– *with my thumb hooked in the belt loop and its tip aimed right at her* –

She said, I'm alright, boy.

– *and when her fingers brushed the sides of hair over her ears I knew I was away* –

She had green eyes and she was not shy and she had numpty little baps – gnaw-me baps – and she must have been about eighteen. She said she wanted to be one of the girls that works in shops. That works in the shops in the town. But I don't know if she had the smell for it, working in shops, those girls are on the fragrant side and smilers and not out of the lanes. Greta didn't smile – I don't think once all night – and she had the smell of the lanes and I made loony faces for her as I fired skittles through the air at the prizes and missed the teddies and packages of treats and perfumes, and she didn't even smile, she just stood there on her long, long legs, in her white dress, and she said –

You're funny.

And I knew that I was away.

What did you say your name was again?

Thomas, I said.

Thomas, she repeated it, but all properly, making a mockery of me, shaping her lips to make it snobby, and all I wanted to do was bite at her lips and fall all the way down the deep drop and into the

green of the green of her lizard eyes – and what I knew was that it would be like stepping off a cliff and into the air.

She was stale smelling – a smell of damp houses – and she stood there on her long legs, in the white dress – and it wasn't the cleanest; my mother would eat me if she saw me laying the hard word on a one like this, because my mother is out of a lane herself, longo, is why – and in back of the big-wheel generator I chanced a fumble and she half-kissed me but I had not waited on the move long enough, I'd gone off too quick, and she pushed me away, and she got a puss on her, and she looked up at the stars above the fair where the sky was breaking and the odd slant of cold rain was coming through for us – it was the end of the summer – and I had more ground to make up.

So I snaked the bottle of communion wine out of my jacket and took the cork off it and said –

In ainm an athar agus an mhic agus an spioraid naoimh…

Amen, she said, and laughed – but even the laugh didn't make her mouth turn into a smile; the laugh didn't reach down beneath the green of her eyes – and she said, where from?

Redemptorists, I said.

And I passed it to her and she tipped back her head for a long draw and a little of the wine escaped down the sides of her mouth and ran red over her lips – Jesus Christ come down off the fucking cross and take me out of my misery – and she wiped her mouth, and she looked at me, and I felt my stomach hit the ground, and I said –

The Redemptorists always did a very nice drop, girl.

It was the last night of the fair, and she would not tell me which lane it was that she lived in, and how was I ever going to find her again if she would not tell? Out of all the lanes of the town, the never-ending turns and the backways and the web of the town, the way it was laid down, how would I ever find her?

She said maybe you'll see me down the shops, and I said maybe I will and maybe I won't, coz maybe I'm going to Birmingham, girl, and maybe you won't see me again.

So will you not come and meet me, Greta, I said, maybe on the Tuesday, by the Stella, and I could take you for a walk or something. We could go out the long walk to the fields by the river.

I can get drink, I said.

Ah, she said, c'mon we go on the swirlers and don't be foolish and we finished what was left of the altar wine and I tried to kiss her again and she brushed it away, and I chanced the hand and she left it there for half a minute – or more – and she looked me in the eye and did not smile.

We rode the swirlers and she did not smile.

A boy was stabbed by the generator and the air got dark and heavy for a while.

I took her to see the devil's disc and she said she wouldn't like the look of it, not one bit, but I talked her into it, and we rode it and spun for a long while, and the wine had us a bit sick and dreamy, and I said things into her ear that I hope she only half-heard, and it was the last night of the fair, and I would never see her again but we turned for a long while, and it was as if it was just the two of us – the way the world moved out and away from us – and we spun and the sky turned and cleared and the stars spun and we were dizzy and when we tried to sit up again we could not, we had spun ourselves senseless, and we were falling back, for a long while, for such a long while, Greta and me, we were falling back and collapsing with love.

St Jerome by Bartolomeo Passarotti

Long gone it would seem from the lights and influences of the sun and the moon, the curious lamps of our days and the main instruments of 'old-fashioned' painters, yet I revere and love him still, my grandfather, Matthew Barry.

A man very much of certain fixed orbits himself, a clement planet who moved between Morehampton Terrace, where he lived and had his studio, the Great South Wall where he often painted lighthouse and sewerage plant with equal respect, the Mont Clare Hotel where he had his lunch, and the sombre palace, with its secret fires, of the National Gallery on Merrion Square.

He was never made RHA but in many years contributed a beautiful watercolour to their annual exhibition. He had been on an 'Imperial scholarship' to Goldsmiths in London when still a young man, studying there alongside Sean O'Sullivan. Before independence Goldsmiths' College gathered young painters from all parts of the empire, and he was one of those lucky pupils, even though his own father, then in his sixties, joined a Cork brigade of the Irish Volunteers in 1916, as he may have done himself. He was devoted to De Valera subsequently, and imagined an Ireland not of Yeatsian fishermen but of civility, polished shoes, and hats raised to ladies, and the old language restored – a noble enough aspiration in a man born in a tiny house in Cork city not many yards from where James Barry, with whom he humbly claimed cousinage, had lived.

Nothing has ever quite compensated for his absence from this world. But since we are all mere visitors, we may say that while he lived, he lived with an extraordinary nicety and kindness. Too poor to buy oil paints regularly, he made a consummate art of

watercolours, and even devised a way to paint in them that resembled oils, though he infinitely respected the essential fleetness and lightness of the junior medium. He also collected bits of debris at the South Wall, old hubcaps and other small objects discarded by their civilization. He set up one hubcap on a wall as if it were a mirror in Van Eyck, and he set others into the grass in his beloved garden so that birds would come and drink, and then he would lurk mightily in his studio above, drawing them, drawing them. He always bid me be still as a statue, so as not to scare them away while he worked, because he said 'You cannot put the birds back in the garden'. His notebooks here and there show half-finished sparrows and black-birds – possibly when his fidgety grandson was visiting.

The found objects he displayed on small shelves, an installation long before such a word was invented. Nevertheless he believed Picasso had taken a wrong turn, and all his own faith resided in draughtsmanship, in virtuosic skill and the religion of verisimilitude.

When I was a teenager I was apprenticed to him, and was taught the mysteries of highlights and the sequences of composition. When I work in the theatre I always think of him – of light and darkness, and what both do to the human body. When I write in long hand I think of him, who had the most beautiful writing, and myself with my impenetrable scribble worse than a doctor's. In many things I refer to him, like a secret manual of how to live and how to make.

Our favourite painting when we went together to the National Gallery was of St Jerome. I loved the lion and the beard of the old man, which reminded me of my father, my grandfather's son. But look at the bird that has strayed into the painting, in the version by Bartolomeo Passarotti.

Don't move, St Jerome. You cannot put the bird back in the painting.

You cannot put the grandfather back in the world but you can give him life in your heart.

Bartolomeo Passarotti, 1529–1592
St Jerome, 1560s
Oil on canvas, 183 × 135 cm

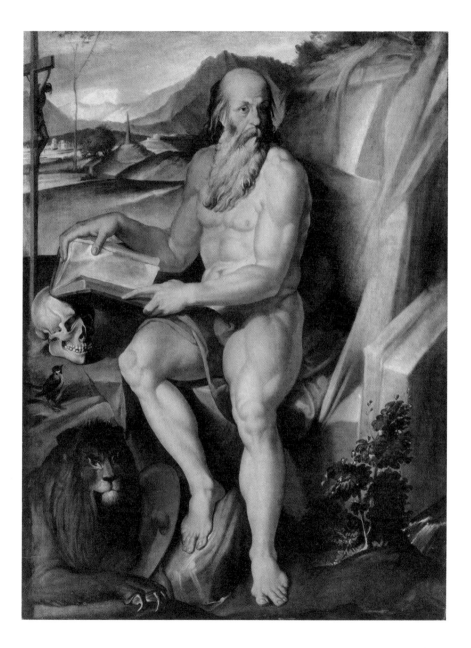

DERMOT BOLGER

Jack B. Yeats's *Grief* (1951)

Someday each one of us will stand amid this:
Indigo blue shards of grief, a blistering deluge
Of mustard flecks of rain that seal us within
A bewildered state which we desperately need –
Yet so desperately fail – to make any sense of.

Jack B. Yeats, 1871–1957
Grief, 1951
Oil on canvas, 102 × 153 cm

EVA BOURKE

Gallery

Quiet empty rooms,
the parquet floor creaked
under my feet only, and all the food on the tables,

the knives, pewter plates, lobsters
and hams, grapes, overripe
and bursting with sweetness,

lay abandoned, just the curling lemon peel
still swayed a little. Tears of condensation ran
down the overturned wineglasses.

There was plenty for everyone
in the universe of colour, a banquet for all
the hungry of the earth and time to eat it, more than enough.

. . .

Wilted petals, insects, partridge feathers
fell from the pages of my notebook and hare's
blood dripped through my hands.

. . .

The girl standing among scrubbed vessels dreamed
of something marvellous – something that
approached her on tiptoe and placed a hand on her shoulder.

. . .

A glint of light in the pupils of the man
holding an orange blossom between pale slim fingers; his love note
was being read by a woman in cold silks on the opposite wall.

. . .

I had come to see my ancestor stand before the ghetto wall anno 1526.
His black velvet collar pulled up around his chin
he coughed into a blood-stained handkerchief.

The wall remained but who remembers him, his rank at court
his services to the archduke? Pigeons muttered on the sills
and the archives of forgetting in the cellar rustled.

. . .

All tried to escape from the frames, children, men on horseback,
kitchen maids, even the snail by the angel's right foot who crept
the wrong way and missed the miracle,

and the young mother wished she could step out of her niche
hand the baby across the sill to the custodian for just a minute
and shed the golden monstrosity that gave her headaches.

. . .

Clouds on their way towards a port just out of sight – Rotterdam perhaps,
a fleet of sail boats adrift on the surface of morning
carrying the news we had long been waiting for.

. . .

A pair of earrings, a drop of sun, windfall apples under trees
a village in the crook of a river's arm,
all the round painted earth.

Wolfgang Huber, *c.* 1485–1553
Portrait of Anthony Hundertpfundt, 1526
Oil on limewood panel, 68.6 × 47.6 cm

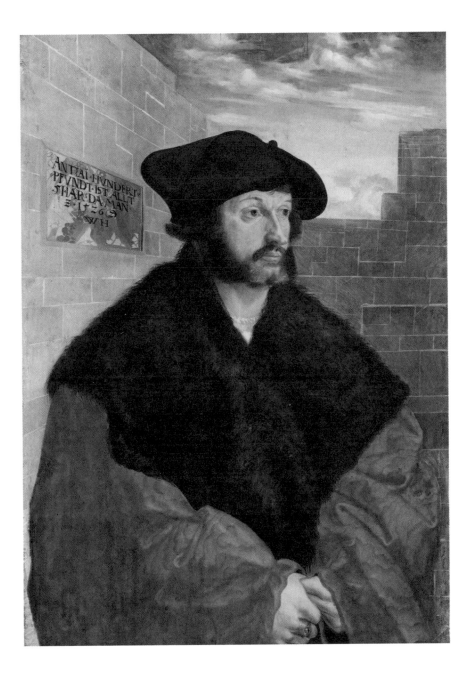

JOHN BOYNE

The Poachers

He was five the first time his father took him into the woods.
Make a sound and you'll regret it, the old man said. The
boy nodded, kept his lips tightly sealed. He knew what it was to go
against him. The man stretched both arms in the air and held them
there, closed his eyes, sniffed the air like an animal. Pointed at a gap
between a clump of trees. Over there.

He watched when they caught him and stood with the tenant
farmers when they threw a rough gallows together, tying the noose
around the man's neck. He didn't turn away when his father's legs
danced in the air for longer than people thought was right. The
pleasure they took in a hanging turned sour when it took a man too
long to die. Those on the platform had had the good grace to look
ashamed of their knotting techniques.

The boy was glad they never took the hood off him for that was
a sight he didn't want to see.

She who used to look in on them of an evening took pity on the
boy. She who stopped coming altogether when his father grabbed
her one night and took her into the room that he'd shared with the
boy's mother before he'd put her in her grave, doing things to her
that made her scream until he put his hand over her mouth and said
if she spoke a word of this, then she'd never speak again. Now she
said the boy must come and live with her and he did and he was
grateful for it but he left when he came of age and moved away, to
another place, somewhere distant.

He met a girl who reminded him of home and took her out
walking. The blue of the sky, the green of the hedgerows. A cres-
cent moon on a fine night. Her father asked what his plans were and

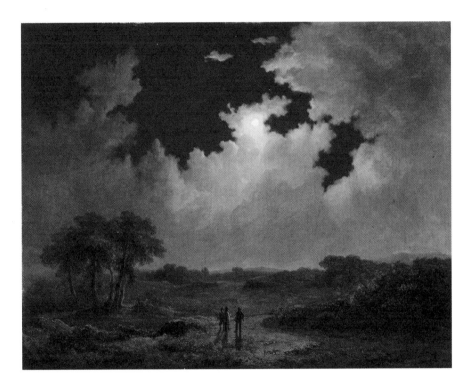

James Arthur O'Connor, 1792 – 1841
The Poachers, 1835
Oil on canvas, 55.5 × 70.5 cm

he said he'd farm if he could get the land but where he'd come from all the land was taken and the old men trapped the widow women into selling below cost once they caught the sniff of a death. And where's that then, the girl's father asked him, where do you come from? Away over there, said the boy, now a young man, nodding in the direction of the sea and telling about a place that seemed mythical at such a remove, as if he might have made it all up from a good dream turned sour.

He married her when she found herself in a condition. Her father had threatened to murder him and a priest had been called. A blessing instead of the last rites was agreed upon. There wasn't one of them in her, there were two, and he wondered what he was going to do about that. He could barely take care of himself, let alone three others.

The girl's father gave him work, work that he hated. The girl's brothers laughed at him, said they knew his sort, that there was nothing new under the sun. When the old man died the brothers said there was nothing for him there anymore and he booked a passage home, taking the girl and the two screaming boys with him, those boys who reminded him badly of their uncles, those boys who slept in a bed together every night and wouldn't be parted.

She who had looked out for him as a child could scarcely believe he was back. You've grown tall, she told him. The spit of your father.

I'm nothing like him, he said. Will there be work here, do you think?

Precious little, she told him. But you might find some.

He found a bit, here and there. The boys grew up and they seemed simple in some way. Wouldn't go to a dance, wouldn't talk to strangers. Held hands together; a queer idea. He thought there was something amiss and when he said as much to his wife she took a knife from the table and told him if he ever said such a thing again she'd run him through with it, as God was her witness, and he believed her too.

And now the boys were men and he was getting older and there was nothing to eat unless they caught it themselves. He went to the woods and did what his father had done before him. He closed his eyes, stretched his arms out, sniffed the air. Found tracks. Chased them down. Waited. Trapped. Drew blood. Skinned. He left no trace. He came home to them with the food around his neck, Jacob with the goatskins on his body. His wife sitting at the table with her needles. The two boys side by side before the fire, watching the flames, whispering things to each other. Private confidences.

You better take them with you some night, she said. They'll not learn on their own.

It's no life for them, he said.

There's no other, she told him.

So he did what she said. He made them dress in green and brown, clothes that blended into the landscape. They wore tall hats and carried a rifle each, the boys huddled together, one looking forward, one looking back. The man separated from them both.

You have to wait, he said. You have to be still. You have to understand movement. This is a good night for it, he told them. Look at the moon. Let it guide you. Remember that they can see you better than you can see them. Don't make any noise, do you hear me? Make a sound and you'll regret it.

He felt a strangeness in his body as he spoke; could feel his legs dancing in the air already.

The spit of your father, she'd said.

MOYA CANNON

The Singing Horseman

The white horse, with its golden
chest and head, is from another world,
is kin to wide-winged Pegasus,
or to the white horse that carried Oisín off,
or to the black mare of Fanad,
who saved her rider from a demon.

But this golden-headed rider is one of us,
a young man with a torn, red sleeve
jogging home, bareback, from the races,
on a breezy summer's evening in Sligo,
riding near the rough blue shore,
heading north towards Streedagh,
playing a whistle or singing
and the painter, who paints them both,
is an old man who remembers a hundred races
a hundred summers' evenings.

But how are we, who do not believe
in magic steeds, to understand this,
except to remember the years,
between fifteen and twenty-two,
when our spirits strained as a moth's
wings strain inside its brown, spun, prison,
when a song –
 pressed into black vinyl
 by some Dylan, seeking his direction home,
 or sung by some acquaintance at a party,
 who gave voice to a long dead passion –
released our crumpled spirits,
transported us across skies and oceans
and our hands, our heads,
were golden, golden.

Jack B. Yeats, 1871–1957
The Singing Horseman, 1949
Oil on canvas, 61.4 × 92 cm

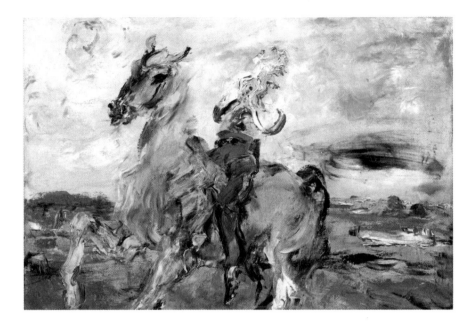

EVELYN CONLON

What Happens at Night

L ast night I dreamed the wrong dream, an easy enough thing to do here, what with all the birds and the weather and the pain, what with all the colour and the history. It happens sometimes, caused maybe by looking across the room, last thing at night, and seeing on your neighbour's face a new loss that you hadn't seen before. You think, looking at me, with my toy and my blue eyes, that I have nothing to dream about. You think my faraway gaze is for your benefit, fixed so you can put your thoughts into it. You do not see that I am hiding the things that I know. And you think that I sit here alone, bound by my frame. You don't think of me talking and sleeping and dreaming. You think I'm the same each day.

But that's not how it is at all. At night, when the last of the uniformed men go home, we take some moments to ourselves, sigh a bit and then prepare to tell each other what we can. We are always very careful to wait some time before we do; we listen to the settling of the floors, tired after all the trodding on them. We check that the hissing down of the heat is not a man come back for his forgotten coat. We take our leisure before we converge with our thoughts. It is often left to me to signal when the coast is clear – I've always been sensitive to sound, indeed I believe that this is why I was made, to create a silence out of the hubbub of Paris, the clash of Dublin, the bustle of men and women as they prepare to be patriots. And when I give the signal our evening begins. There are some who remain passive, aloof, too wrung out with experience to venture small talk. There are some who burst into blazes of noise, full of excitement and glee, flying this way and that, making no sense at all, but enjoy-ing themselves doing it. I am somewhere in-between.

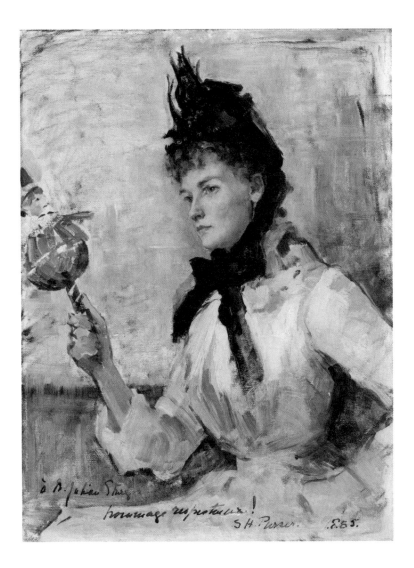

Sarah Purser, 1848–1943
A Lady Holding a Doll's Rattle, 1885
Oil on canvas, 41 × 31 cm

And as the evening goes on of course we drift towards our special friend, mine is at an easy angle to me, I can keep watch with him, the big emigrant ship, as he waits for the small boats with the small people, as his sailors prepare for departure, as the noise of him and them mix into one thing, seldom letting us hear any weeping. It's not often that the passengers see me, although occasionally some glance hurriedly in my direction and catch for a moment a stray note on my face that reminds them of a thing they have already forgotten. They are very busy, you see, digging holes for their hurt, managing their griefs, and sometimes having bursts of longing as the glow of the sun strikes across their faces.

When it comes to sleeping time our calls to have good nights are hushed. We know that some have already shut down; closed their eyes and their mountains, folded their colours, horses stabled or asleep on their feet, wars over for the night. And our wishes to each other are meant. But something went wrong in the rhythm of all this last night. Just as I was curling into my silence, a woman from one of the small boats called out to me. That's not a usual thing – certainly not from those quarters. In fact it's a rare thing for most of us to speak – we tend to use subtler ways for trading thoughts. We're good secret keepers too, hearing the most extraordinary things as people drop their guards before us and let out the most precious of free thoughts. The woman from the boat – she's at the back of the one closest to the ship – shouted that she had seen the future. She said that, in general, it had its ups and downs, but that her own particular one worried her, she hoped it was not going to be true. She shouted that the world was full of sharks, ready to devour us, determined not to let some of us speak and that's why she was telling me. She said it was important to believe that the future she had seen could be changed. She asked me to keep true to her. But then a wind blew up, the sails flapped noisily and I could hear no more. This is why I dreamt the wrong dream last night, seeing all the dangers that she meant, seeing her future before it happened. When I woke this morning, dissatisfied, the light was off my face.

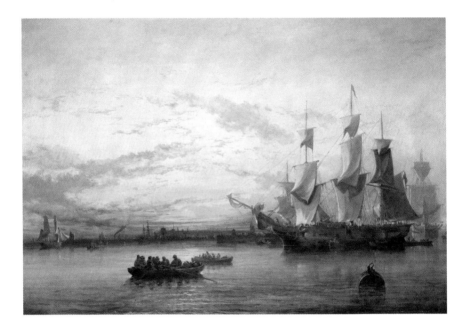

Edwin Hayes, 1820–1904
An Emigrant Ship, Dublin Bay, Sunset, 1853
Oil on canvas, 58 × 86 cm

I could already hear keys in doors, scraping shoes and a gust of children before I even had the time to sit up straight and settle my pose.

Now I will have to wait all day to find out how she thinks I can keep faith with her, because I would like to. And if she thinks that knowing the pitfalls will save us. A woman with a future like hers is bound to know. I hope she's not already on board by the time this evening comes. People will be stopping in front of me all day, obscuring my view. But perhaps I can send a message over their heads. Maybe they will not hear what she calls back to me – it might alarm them if they did. Or maybe I could borrow a bird, a pigeon to take our notes to each other, or maybe I could make a code of my toy. Yes, maybe I'll be able to do this to-day and then it will be possible for me to dream the right dream to-night.

PHILIP DAVISON

Cordélie

At the time of the encounter Cordélie worked as housekeeper in a hotel in the seaside town of Le Touquet. Arnaut was a Parisian lawyer, successful beyond his tender years, some would say. All who knew him acknowledged that his success could not be wholly explained by knowledge of the law and ruthlessness. Cordélie had met many men, but none so willful, so melancholy and so beautiful.

She was brave and followed her desire. She told Arnaut she had observed him on the staircase and landing in the hotel, and walking the promenade. She had studied his body in motion – this was the phrase she used.

'My father is ill,' he confided. 'He will die soon.' He told her that he felt nothing for the old man and that this was inexplicable. He spoke as though he had a crushing weight on his ribs.

'Where is your wife?' Cordélie asked. She had seen the wedding ring on his finger.

'We are not together.'

She looked away, out of deference, perhaps. 'We are lucky we found each other,' she dared to say. She was anxious to make something of their different circumstances. She moved quickly to draw him closer.

'The problem with good luck is that we learn nothing from it,' he said. The remark was not intended to be cutting or unkind. Cordélie understood this ruefulness.

'The problem with bad luck is that it is bad,' she promptly replied.

He was impressed with her forwardness and with the firmness of her lavender-scented bed.

Gabriele Münter, 1877–1962
Girl with a Red Ribbon, 1908
Oil on board, 40.7 × 32.8 cm

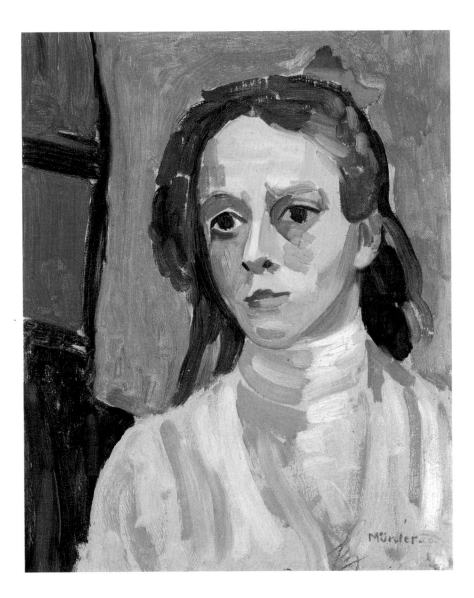

Every day Arnaut walked on the beach just after dawn. The stretch he chose was some distance from the town. He wanted no company. He made that clear to Cordélie when she offered to walk out with him. She was not from the region – she was half German, in fact, though few would have guessed as much. In any case, she could do as she liked in her time off, she insisted. And, in good company she was capable of being silent, however long a walk might take. She would bring wine, bread and fruit. He could watch her eat and drink if he wanted none of it.

On the day that mattered most she was not in Arnaut's thoughts as he made a march of his troubles on the dry sand between the dunes and the wet flats. The beach was deserted. The yellow autumn sun was still below the horizon.

He did not break stride when he saw the dark, crumpled heap near the water's edge several hundred yards ahead, but made it his mark. It was the body of a middle-aged man in a heavy coat. One arm was stretched fully above his head. The other, crooked under the torso. The face was three-quarters turned into the sand. Arnaut heaved him onto his back, then put his fingertips to the side of the man's neck to feel for a pulse, knowing it was futile. He was surprised to see that his fingers knew where to go. The man was cold, salty damp, stone dead, but the sea hadn't washed him up. There were deep footprints visible. Their track led back to a cut in the dunes.

Curiously, Arnaut felt no sense of urgency, No panic. He had been presented with a special duty, which he would respectfully discharge. He took the body up in frontal bear hug. There was a sweet and sour smell to the flesh. Pickles and talcum powder. There was a smell of spent tobacco. The dead man's arms came up over his shoulders in the manner of a drunk signalling for help. Trapped air was expelled from the lungs. It came out as part gurgle, part groan. Arnaut faltered, but did not let go. He did, however, accidentally stand on a foot and almost fell over.

'Sorry,' he said nervously.

The tide was coming in. Arnaut dragged the body up onto dry sand, losing one of its shoes on the way. He fell to the ground with it. He lay beside it for a moment looking into the glassy eyes. This was a terrible intimacy, but he was able and this was an honour. He retrieved the lost shoe, put it back on the foot and tied the lace. He did not want to abandon the body. He wanted to make conversation, but instead, sat in silence until someone else appeared and recovered them both.

Later, when Arnaut told Cordélie what had happened her eyes widened with wonder.

'What did it feel like, sitting with the body?' she asked. 'Like nothing,' he replied with uncharacteristic vagueness, but she saw he had been affected deeply.

Next day he took her to the beach. But, of course, there was nothing to show her. No trace. They could only recreate the silence. Independent of each other they looked left and right. Then, together, they settled on one vacant spot on the sand. She leaned in to kiss him, but already she had lost him.

That afternoon, Arnaut went to the police station to make his formal statement. Cordélie never saw him again.

The following day Cordélie was let go from her post at the hotel for fraternizing with the gentleman guest. She left Le Touquet and travelled to the Bavarian town of Murnau where she stayed for a time with her father, a man she scarcely knew. She thought about her estranged lover and his foundling dead man. She imagined Arnaut at his father's bedside fearing he had no proper feelings of privilege or honour, imagined him deserting the old man the night he expected him to die, imagined Arnaut travelling a long distance to seduce his estranged wife, imagined him returning to his father's bedside, the old man still determinedly alive.

Cordélie wished in vain that Arnaut would open to her as he had to the stranger on the beach, but she was no fool. She was brave and could be gentle with herself. In time, she might feel nothing, but until then, early each morning it would be the same imagining. The same compassing.

GERALD DAWE

Paul Henry, *Moonlight*

When I roll over to your side
 of the bed I could be crossing
a moonlit strand in Mayo.
 Then I think again.

Far from the likes of Killala,
 the tide is really just where
you and I are standing alone,
 as still as anything.

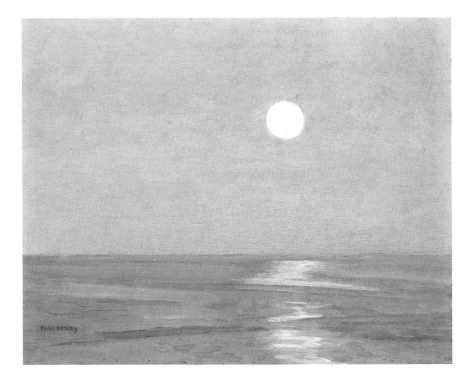

Paul Henry, 1876–1958
Moonlight, 1926
Oil on board, 34 × 43 cm

JOHN F. DEANE

Night Prayer

Rembrandt: *Landscape with the Rest on the Flight into Egypt*

I

This, too, you see, is prayer, these words I labour to admit
 under the spirit's prompting, words on the notebook
 difficult to decipher, the ink flowing out too fast

in the first stirrings; pen, copybook and keyboard
 in an attempt to touch the source of light,
 of life, the groundwork of our hope. Here, too,

II

figures in a nightscape, a pause in the difficult journey; questions
 of resting in penumbra, of knowing light is fragile,
 like a child holding its greedy mouth to the breast;

there is a fire of sticks, trouvaille of twig and branch, to keep
 wolves at bay, (between here and destination, Emmaus, say,
 beyond a life's full circle, light against the darkness) and this

III

is Jesus, name and nature of our source and sustenance, this
 is God, dwarfed by trees and distances, enormous landscape
 and a darkening night, and you grow aware that here the

watchful small lamps of greed and power are looming over all.
 The canvas, too, is prayer, impasto, brush and palette knife,
 working to ease the blackness about the light, cognisant

IV

of the death of innocents; it is all self-portrait, still life, a halt
 in the hastening, the helplessness of humankind before its own,
 the helplessness of God trusting Himself to flesh;

love is a small child, far from consciousness, hunted; should he be
 found and killed, what then? what then? Rembrandt
 knew that distance between himself and God – all time, all space, all

V

life, all death – had been too great; the instruments of art, sharpened and
 softened in the desiring heart, shorten the distance, finding
 a sheltering tree, light shouldering the darkness; this

Egypt of the imagination, this den of safety called
 exile, as world with its instruments of power and economics
 preys on you and how can you believe your pigments

VI

touch beyond impossibility? Image, less real than
 thistledown in a western gale, less permanent than golden light
 reflected on a pond, you try to empty the ocean of silence

with the holding power of pigments, the silence that is God.
 Christ-beyond-all-grasping, the heart in its pleading is a series
 of shifting darkscapes, vaulted in night-prayer passageways.

JOHN F. DEANE

Rembrandt van Rijn, 1606–1669
Landscape with the Rest on the Flight into Egypt, 1647
Oil on panel, 34 × 48 cm

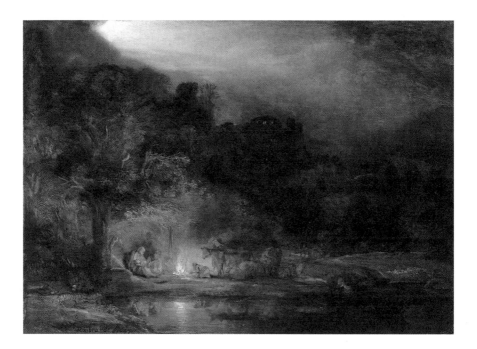

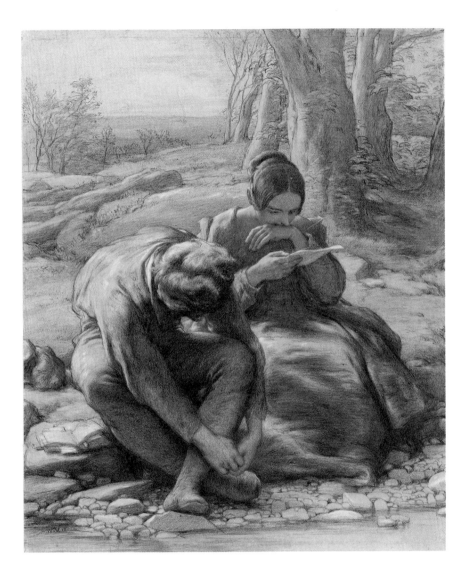

William Mulready, 1786–1863
The Sonnet, c. 1839
Graphite and chalk on paper, 36 × 29.9 cm

GERARD DONOVAN

William Mulready's *The Sonnet*

An appreciation

When William Mulready titled his drawing *The Sonnet*, he chose a literary form in decline. Once the choice of masters such as Petrarch, Shakespeare, Spenser and Milton and with its renaissance ahead of it in the hands of Elizabeth Barrett Browning and Christina Rossetti, the sonnet had for a century outlived its voice. If what remained were archaic references and sentimentality in the work of aspiring poets, the cure was ridicule.

Understanding the sonnet's attraction is not difficult. Obvious is its wonderfully compact, efficient architecture: a finished sonnet fits neatly on one page. The English version contains fourteen lines, each with ten syllables organized in a sing-song iambic rhythm, further tightened by a rhyme-scheme into four verses (quatrains). These first twelve lines are designed so that the speaker may detail a crisis or confusion. But the final two lines, a couplet, come to the rescue with a resolution, often a declaration of enduring companionship in the face of trouble; for the sonnet is associated chiefly with friendship, love and beauty, something to be written with care and tendered after rumination and hesitation – in theory.

Some drama is built into the structure. At the end of the twelfth line, when the situation is dire and the poem closing, an energy intervenes. Call it the engine of the sonnet, a lever, an oar dipped that powers a hopeless situation across to the saving grace of the final two lines. In a stroke, the poem arrives at its moment of transformation and revelation, and a greater perspective overcomes despair. A sonnet lives in that singularity, the 'still' of insight, the fraction of movement. As the painter and poet Dante Gabriel Rossetti put it, the sonnet is a 'moment's monument'.

In the 1830s parts of England registered a pause between what we call now the first and second industrial revolutions. Industry was adopting a recognizable form of production: the rise of the machines and techniques of mass production in factories. Machinery offered a reliable system of manufacturing with a predictable output and quality. The human model was less reliable.

Sonnet-writers and the machines face off only in our imaginations – poetry as the hollow cast into which words are poured – as on a production line – where sameness is a virtue. Even in the imagination, that prospect is depressing. So I wonder why William Mulready chose his title, which reveals that the communication under review is a dreaded sonnet.

A woodland setting. A young woman reads the lines her shy suitor has written, and he observes her reaction. Their clothes are simple, the trees threadbare, and his diary is stuffed with other writing. He is deferential beyond a poet's natural shyness, which suggests a progressing friendship. Yet Mulready pulls the eye unerringly to the drawing's centre of gravity – her expression. Even the poet leans out of the way.

Keeping in mind the structure of the sonnet, we can see that the woman's gaze hovers near to the end of the page, which means she has come to the final two lines, the poet's declaration. Her hand, palm down, stops her from speaking, it masks her shock or delight – we don't know. A palm up would suggest mirth. We will never get past this moment, but they will. The poet's head is level with the page, and because he has no reason to look around, his expression is not ours to see, just as we cannot read his verse, nor do more than guess what comes next from her.

No fulcrum can remove him from his moment of inertia – only she can do that. The viewer too is left stranded between the twelfth line and the couplet. This remarkable drawing is a physical representation of the sonnet form – the captured moment between reading and reaction, friendship and love, innocence and experience.

Perhaps Mulready is suggesting that poetry always has something

important to say, and that its most important utterances are made at small junctures amongst small lives that lie forever out of sight. If so, he fashions an artistic democracy out of love. No princes here, no grand historical backdrop. More the plain lyricism to which the sonnet itself would soon return.

The finished oil painting for which this drawing was made can be found in the Victoria and Albert Museum. The brief descriptive summary concludes with a quote from a critic of the artist's time: '…the merry maid who reads them…placing her hand before her lips to suppress her laughter'. But to accept this interpretation, we must accept that hers is a capricious young mind, and that she is aware of the sonnet's decline in literary circles. Finally, we must conclude further that William Mulready trades on that sarcasm. I see no evidence to support such extrapolations.

Critics, by their nature, too often 'see' art using an algorithm that attributes to it the identifying marks of their own social circles, their own influences and obsessions. To some degree they are compelled to evaluate by employing simple comparisons: a painting to a different work, or to a theory, school or period. The temptation is to align art along the grid they assume exists, and to attribute to that alignment a *meaning*. In pursuit of that end, they are fully capable of sidelining the work itself.

Artists enjoy a different relationship with the Zeitgeist. A painting breathes every time it is viewed, and the best paintings survive generations, not because of meaning, but because of emotion transferred through a human act of recognition. Aristotle has much to say about that process.

The human expression betrays the instant of feeling, and human feeling is a constant, unlike the masks and subterfuge available to language. She is not reviewing a sonnet, she is reading *his* sonnet, and I have no doubt that she is part of it. Perhaps visual art at its best preserves these flashes of humanity from lives long gone, as this wonderful drawing does so well. Ennis-born William Mulready has taken a degraded symbol out of his time and given it a new life, in ours.

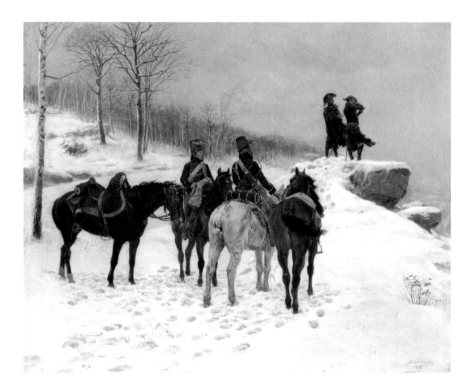

Ernest Meissonier, 1815–1891
*Cavalry in the Snow: Moreau and Dessoles
before Hohenlinden*, 1875
Oil on panel, 37.5 × 47 cm

THEO DORGAN

Ernest Meissonier, *Cavalry in the Snow:*
Moreau and Dessoles before Hohenlinden

I am constantly drawn to this quartet of horsemen, indulging a
habit founded in childhood, when I'd bunk into the Crawford
Gallery in Cork in the days when unaccompanied children were
the enemy, to be routed out as soon as seen. The thrill of the illicit
became tangled up in my child's mind with something no book or
magazine illustration ever prompted: a dizzy and overwhelming
urge to throw myself into a painting – and I mean throw, here; the
same kind of abandonment I would feel when launching myself
across the shimmering gulf between one great elm and the next in
the fields behind our house.

So. No sooner do I stand before this small painting than I am
overcome by some adult version of that same irresistible urge: I
let myself go, I plunge in, I am drawn up into fields of winter, to a
high ridge overlooking some unseen valley, these forceful mysteri-
ous men before me, the hot smell of horseflesh, the child's inborn
skepticism of authority at work in me as I gravitate towards the
equerries, keeping a wary eye on their superior officers. Men on
horseback, cavalrymen! Such bright attractive green uniforms, how
calmly they sit their horses, how I should like to sit a horse like that,
nonchalant and solid. I feel the cold on my face, the deep cold I first
felt in Austria many years ago, cold coming down off a steep crest
crowned, as this one is crowned, with greysilver birch.

And then, as the years pass, and that uninstructed self is tem-
pered by a more learned self, the joy of seeing also what Meissonier
is *doing* here, of seeing how this miracle of otherwhere is achieved
by the application of paint, the laying-on of tone and colour, the
massing of forms, the interplay between form and tone, how one

reinforces, interprets, the other. And past that again, I find myself drawn twice over to those officers at that point to which the eye is so skillfully led. They look so…capable, is it? So *there* and *detached*. How not to identify with those austere uniforms, that supreme air of knowing what's going on. The one with the telescope, so full of purpose, an eagle's intentness and an eagle's point of view – and that other, his companion, so sure of himself, so confidently braced inside the armature of his sinews and bones.

And if it were me, that cold brass telescope pressed to my eye, so languidly balanced there on that ridge, so tautly attentive? What might I not be looking at? A battle in progress? No, the scene too composed for that. A sky full of snow above them all, on what will it fall, tonight or tomorrow?

I move about inside the painting. I observe the blanket roll on the grey's saddle – *campaigning*, I think, they have not ridden out from barracks. Nothing rolled up behind that officer's saddle? Ah but of course, an officer's shelter will be provided for when the common soldier may expect to shift as best he can. No? Perhaps not, but finding the thought in myself I see I have switched identifications again, from the officers to the men. It is a fallacy, I think, to assume that the viewer will always seek out the hero with whom to identify. The painter may intend it so, but there is a liberty to refuse, all the more so if, like me, you are inclined to consider the painting a portal to a three-dimensional space.

When you go in there, you bring with you who you are, all those scraps of learning, affinities, identifications and inclinations.

So, I veer between men and officers, now blown this way, now that, on whatever winds may be billowing on the day.

I ramble, I float and muse, I go now this way, now that way, entirely at liberty, sensing and feeling spaces way out beyond the frame.

But back now…

So solid that grey, muscular, capable – a good horse to carry you in a charge, where weight as you crash through the opposing ranks is advantage enough to make, perhaps, all the difference. Look at that now, I think, see how these scarlet shakoes are connected by a cord to the men's jackets? Ah of course, difficult to keep a hat on your head at the gallop. So, some imminence implied here. *Tomorrow in the battle think on me.* The sabre of course hanging always to the right side so that a right-hander, drawing it, will not get tangled crossing himself in the reins.

There's a self riding down out of the picture, no, two selves. One of them shakoed, stolid and wary, wondering what these damn officers are about to get us into. Feeling the wide flanks of this solid grey with my knees pressing inward, rolling my shoulders against the cold, careful to keep my expression neutral. The other, say Moreau, languid, withdrawn, my mind on the disposition of forces, on calculation, imponderables, on tomorrow.

Riding a good horse downhill through snow. On the eve of battle – because I looked it up, I know who Moreau is, Napoleon's General, a loyal Republican in and out of the Emperor's favour. And I know about Hohenlinden, so my mind is full of the coming battle, my sympathies with men breathing this cold air tonight who will not be breathing it tomorrow.

All this and so much more, so very much more, out of one small painting – and I close my eyes for one brief instant, leaving the gallery, not sure when I open them where I shall find myself, on a Dublin street, so long familiar, or on a wooded slope with a sky full of lead-heavy snow above my head, hearing the creak of leather beneath me, feeling the solid heat of the animal bearing me down off that crest towards some tomorrow at once unknown, unknowable and absurdly unfamiliar. Dancing with the child I was, cheating the monoworld.

RODDY DOYLE

A Morning in a City

It got harder every day. It got harder and harder to look at each day, to walk out into it as if it was new and he was glad to be walking into it.

He tried.

He shaved. He polished his shoes. He examined his coat and kept a brush beside the front door, to get rid of any dust or dog hair.

He tried. He did. He tried to be the man he felt he'd always been.

He stood on the street every day and tried to recapture it.

The feeling. The conviction, the opinions, excitement. Most days he did this, every working day.

He never lit up until he was out of the house.

He never missed a day of work.

The dog had been gone for more than a year but the hair still lingered. A bit like the opinions, the excitement. Long gone, just dry words.

He pushed that thought away.

Every day.

Oh God.

Rituals held him up. Rituals made him a man. Got him out of bed. That was one of them, actually. The waking, the getting up – he never needed the alarm clock. The night before had never made him late or reluctant. The clock was there but set to his wife's day, not his. He put his feet on the floor. He could read the day ahead by the cold of the floorboards.

He stood up. He took his dressing gown from the back of the chair. He put it on, tied the cord, went down the stairs to the kitchen. He missed the dog, unlocked the door and went out to the toilet. He came back in and filled the kettle, enough water for tea and shave.

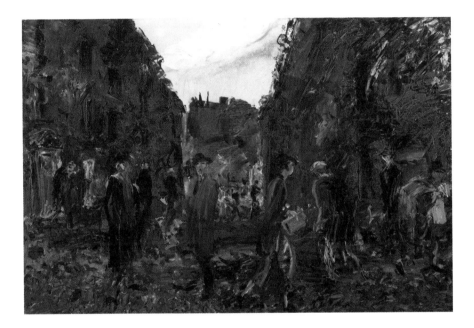

Jack B. Yeats, 1871–1957
Morning in a City, 1937
Oil on canvas, 61 × 91 cm

He didn't eat. He couldn't.

He brought tea up to his wife before he left. He put it beside her. She'd know he'd put it there. She wouldn't drink it; it would be cold by the time she woke. But he did it anyway, every morning. It was the ritual, the message. He thought about stopping. But he wouldn't. He didn't want to leave the space empty on the bedside table, where the cup sat now. He never wanted to do that.

It was Sunday since they'd spoken. They'd gone to half-ten mass. Today was Wednesday.

He stood on the street and lit his first smoke of the day. The first of twenty. He knew exactly when and where the remaining nineteen would fit into his timetable. Tram, street, desk, desk, desk, park, park, street, desk, desk, desk, desk, snug, snug, snug, snug, street, tram, garden. Sweet Afton. He'd buy the new day's packet on his way to the tram. It was the only thing that felt the same, as urgent and as necessary, as just plain great as the first time; pulling the smoke down to his lungs. Not the first time. The first time had actually been dreadful. He could almost taste the vomit; the memory made him shut his eyes. It would have been the third time, perhaps, or the fourth, when he became the smoker he was now. He was still the nine-year-old boy he'd been when he took out his box of matches and shook it.

The street.

His home.

Like himself, he thought. A tired, older version of the original. He wasn't tired, just – trapped, perhaps. Frightened. He didn't want to move. But, of course, he had to. He wanted to turn back. But he couldn't. He wanted go back inside, up the stairs. He wanted to wake his wife, he wanted to kiss her shoulder. He wanted to make her laugh. But.

But, but, but.

He had to go. His country needed him.

But. He wanted to stand at the bedroom door and say her name.

He said it now – he thought he did. No one looked.

– Maeve.

He'd go into the room; he'd follow the name. He'd sit at the side of the bed. She'd be awake. She'd feel the cold off his coat and see the steam rising from the cup. She'd smile. He'd lean down and kiss her. She'd take off his hat and throw it across the room. She'd laugh.

No.

She'd tell him to stop. He wouldn't do it in the first place. He'd stand at the door and say nothing. He wouldn't go up to the room. He wouldn't go back home. He was where he was, on the street. He was on his way to work.

No.

He'd kiss her shoulder and he'd tell her he loved her. He'd keep his coat on. He'd sit back on the bed, beside her. She'd lean in beside him. That was all – that was all he wanted. Then he'd stand up again.

– I'll see you later so.

– Yes.

– Bye, Maeve.

– Bye bye, Tom.

He'd kiss her again and go. He'd be late for work. He'd be late all day. He'd be running after himself, laughing. He'd be the talk of the Department, the talk of the whole bloody town.

No.

He had to go. He had to get through the day. There was a man coming up from the country. He'd have to be met and spoken to. There was another man he needed to see. The day was full of things that had to be done. Things, like ledges on a cliff face, that he could cling to as he climbed. That would get him through to night time, and the last cigarette in the garden, and into bed beside his sleeping wife, and the next day.

No.

He turned.

He got to the front door. He got in.

He got up the stairs to the bedroom.

He could feel his heart, and his breathing. The steam was still rising from the cup.

– Maeve?

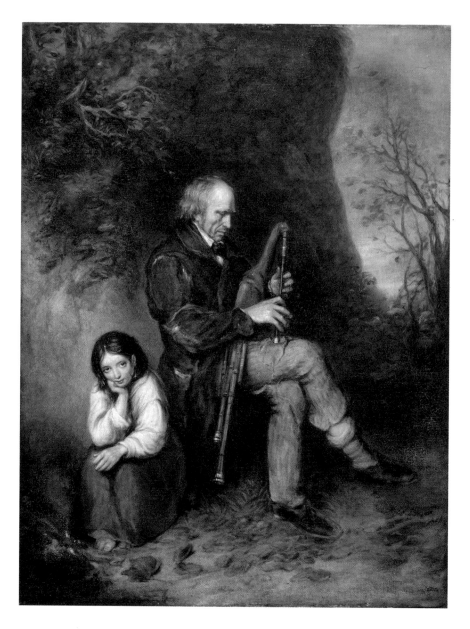

Joseph Patrick Haverty, 1794–1864
The Blind Piper, 1841
Oil on canvas, 76 × 59 cm

BERNARD FARRELL

A Painting and a Poem

I n his poem 'Selva Oscura', Louis MacNeice wrote that 'A house can be haunted by those who were never there/If there was where they were missed.' For many, those words are puzzling but, for me, they had an immediate significance. Just as, some years ago, when I stood in front of Joseph Haverty's painting *The Blind Piper* in the National Gallery I instantly knew what it was saying to me. So, two sources of revelation, a poem and a painting, each unrelated and yet, for me, they once came together to bring some tranquillity into my life.

First, the haunting and the poem.

Twenty-five years ago when my wife and I moved into our house in Greystones in County Wicklow, I immediately felt the presence of my father there. But my father had been dead for many years and had never been to our house and yet, there he was. Not like the ghost of Hamlet or of Marley but, as he was in life, just quietly amongst us. And my guilty perception was that he was there because in one of our rooms were his violin and violin-case – which I had inherited – and that he was therefore around to remind me of a past that I would rather forget.

My father was a very gifted violinist and I remember at social gatherings in our family home in Glasthule how he could bring a room to silence as he began to play. Often, as a young boy, I would proudly observe our neighbours as they sat enthralled, listening to him play Massenet or Schubert or Mascagni and always, at the end, his favourite finale of the Romance by Shostakovich. And although it was never discussed, everybody knew that I would one day take lessons from him and, in time, play as he played and keep the tradition alive.

The lessons began when I was twelve and ended when I was thirteen. In that year, my father's enthusiasm and patience were constantly thwarted by my frustrated insistence that, unlike him, I clearly did not have the gift. And one day, my frustration exploded into a loud declaration that I was tired of these lessons and that there were other things, like football and swimming and friends, which were more important to me than playing the violin.

Typically, my father accepted this rejection calmly but, to this day, I can still see the disappointment in his face as he took the violin from my hands and proceeded to play some gentle piece as I left the room. He never offered me lessons again and I never asked and we lived our lives with me as the adult listener and he the gifted violinist, into his old age.

Then one day – surely prompted by guilt – I offered to record his beautiful playing on a tape machine that I had just purchased. At first, he resisted the idea but then he suddenly agreed and, with great enthusiasm, spent the next two weeks choosing pieces and practising as though, as my mother recalled, he had been invited to play at Carnegie Hall.

However, the recording, when it happened, was heart-breaking. Just as I had never really noticed him growing old, so I hadn't noticed his musical gift diminishing. And neither had he. On the day, he played Schubert and then Debussy with all the concentration and confidence of bygone days, but it wasn't the same. And, for years after, I knew that I should never have played the tape back to him, but I did. He listened, seemed initially surprised, then sadly resigned and when it finished, he silently put the violin back into its case. He did play again, many times, but never publicly. And the responsibility for that added to my guilt and gave me another explanation for his presence in our house and on my conscience.

And then, one afternoon, I stood before the painting *The Blind Piper* by Joseph Haverty and I suddenly knew that, for some reason which I could not understand then, it had much to tell me.

Works of art that arrest our attention, stop us in our tracks and consume us with possibilities are often not mirrors of our lives but rather they are prisms that we subtly adjust to reflect other peoples' experiences in broken parallels to our own. We do not see our past, we see another past and, with a jolting empathy, it can cut to the core of our being, in a reflection of our lives and, sometimes, our loss.

In Joseph Haverty's marvellously sensitive painting, my father is clearly not the blind piper but, in his old age, the hands could be. I have seen those fingers on the strings of his violin, as my tape recorder turned, striving to capture what was already lost. Again, the sightless expression of the piper is not that of my father, it is nothing like it and yet, within it, is the expression of one who hears his music, knows its value and either accepts it gratefully or inwardly rages against its inadequacies. And the listener, the child, is certainly not me – firstly, it is a girl and she certainly does not have the expression that I wore on the day that I rejected his lessons or on the afternoon of the recording. No, hers is a look of pride, comfort and assuredness. But it is also the expression that, as a young boy, I would have worn many times, when my father was at his magical best and I was at his knee, watching him and listening to him in wonder.

So perhaps that is what held me, possessed me, when I first saw this painting, and still holds me today. It is a wish, a dream, created and fulfilled, of my father in old age, playing as he played when his music was still eternally beautiful and I am young, in awe, proudly watching the neighbours enthralled by him and, unlike the sightless piper, he sees me, knows my thoughts, is consoled by my admiration and affection, and all is well.

Roderic O'Conor, 1860–1940
La Jeune Bretonne, c. 1895
Oil on canvas, 65 × 50 cm

CARLO GÉBLER

The NGI Guide

V ictor McGloyn ran with the Glengormley Terrors, a north Belfast tong. Two days after his sixteenth birthday Victor killed a lad from a rival gang with a samurai sword he'd got off eBay.

Victor copped life and started his sentence in a Young Offenders Centre; at twenty-one he graduated to the adult prison, HMP Loanend, and came to the wing where I'm the orderly. I issued him his bedroll and his welcome pack and we became friends.

I liked Victor; he was naive and pliant. He got a job in the kitchens and stole to order for me, including a knife. That took courage *and* ingenuity. He was artistic too. For fifty grams of tobacco he'd copy any photograph, and starting at two five pound phone cards he'd knock up a coat of arms (football or paramilitary), any cartoon character you named, or an Irish rustic scene. I told him to join Mrs Cartmill's art class. He did.

About a year later prison management went to Mrs Cartmill's class to commission paintings for Visits, where prisoners met family members. Management wanted nothing contentious: no portrait of Bobby Sands, no nude copied from Readers' Wives: so they decreed all the paintings must be copies of classics. Victor was asked to do one; he was delighted; he knew that when the finished paintings officially went up in Visits there'd be a 'do' and his Ma would come and when she saw his canvas she'd realize he wasn't only bad.

Victor got catalogues and began searching but he couldn't find anything suitable. It was at this moment Edmund Hartick, who'd got six for VAT evasion, arrived on the wing.

Edmund had a mansion in Hillsborough stuffed with antiques and paintings (all in the wife's name to block the Criminal Assets people taking it), styled himself a connoisseur and had a lot of art books in his cell.

One evening Victor came to Edmund's cell door, explained he was looking for something to copy, and asked to look at Edmund's books.

'Okay,' said Edmund.

Victor went into Edmund's cell and began leafing thorough his books. The third was the Guide from the National Gallery, Dublin, and in here, at last, Victor found what he wanted: this painting, *La Jeune Bretonne* by Roderic O'Conor, showed a woman in a funny hat seen sideways on.

'Can I have a lend of your book,' said Victor, 'so I can copy this painting?'

'Nope,' said Edmund.

Victor explained he'd a canvas in his cell and he must start now. 'I promise I'll look after it,' he said.

'No,' said Edmund, 'That's a favourite book. It doesn't leave the cell.'

Victor pleaded. He got me in to intercede. But Edmund wouldn't budge.

After several minutes wrangling Victor stormed out. I followed.

'It's a famous painting,' I said. 'Mrs Cartmill will get you a copy.'

'Hartick's a cunt,' said Victor. 'I'll fix him.'

Two days later I was in the officer's pod cleaning their Baby Belling stove when Edmund rushed in.

'What?' said Hayes. He was a uniform but I liked him.

'Victor McGloyn,' said Edmund, 'wanted the loan of a book of mine. I refused. Now he's stolen it.' Edmund saw me. 'Tell him about it Chalky…'

Victor's cell was searched. The search team didn't find Edmund's book but they did find Ecstasy. Victor was charged and got a fortnight in the punishment block. By the time he returned, Edmund had been moved to another block to stop retaliation.

Time passed. Victor worked on his canvas when he was locked and when I asked what he was painting he told me that, like everyone else, I'd have to wait till it went up. Then came the day of the

'do' when all the paintings did go up. I wasn't there but I did ask someone who was what Victor had painted: unfortunately, my contact hadn't looked at the paintings at all: he'd been too busy scoffing sausage rolls.

One afternoon, about a fortnight later, the general alarm sounded. As I was being locked (once the bell goes everyone's locked) Hayes told me there'd been an incident in Visits. Half an hour later the all clear sounded. I was unlocked. By evening the whole prison knew it was Hartick who'd tripped the alarm: he'd produced a blade in Visits and gone psycho before he was carted away to the Punishment block. But there was no info on what he'd done. I'd an idea though.

The next day I was in the laundry room across the circle from the pod when I heard Hayes bellow, 'McGloyn.'

I saw Victor go in and then rush out of the officer's pod. Victor ran down the wing and into his cell. Hayes followed.

'Lock me,' he shouted. Hayes obliged

Five minutes later, I went to Victor's door and looked through the Judas slit. Victor was on his bed, sobbing.

'Victor,' I said, 'what is it?'

'My painting in Visits,' he said. 'Hartick slashed it.'

The next morning Victor wouldn't go to work and stayed locked. Hayes called me into the pod.

'Chalky,' he said, 'did Hartick do that because Victor nicked his book?'

He pointed at Victor's painting of the woman in a funny hat that was leaning against the wall, and though it was slashed I saw it was good.

'No idea,' I said, though I was sure he had.

'Did you know Victor paid for the frame and everything with his own money? He was going to take that home when he left, to his Ma.'

'No.'

'Well, Victor doesn't want it now. Bin it!'

'"Welcome to the house of pain,"' I said, as I began to tear the canvas off the frame.

'Where's that from?' said Hayes.

'It was on the wall of my first ever cell.'

'And you thought it meant physical pain but now you're wiser you know in jail we do 57 varieties of agony?'

'Yeah.'

I'd everything in a black bag now.

'Chalky,' said Hayes, 'fuck off.'

ALAN GLYNN

Jack B. Yeats's *The Liffey Swim* (1923)

Dublin in the early 1970s was a colourful place, in the literal sense that it was full of colour – and dizzyingly, almost blindingly, so. Avocado green, harvest gold, sunshine yellow, rust, sandstone, purple, orange. Colour was everywhere, in decor, carpets, fabrics, fashion, appliances, cars, in John Hinde postcards, in the Dandelion Market, in the Celtic artwork of Jim Fitzpatrick. And it had come to TV as well. I remember going into a neighbour's house – the first people on the road to get a colour TV – and it was like that moment when Dorothy opens the door of her dreary monochrome house in Kansas and steps gingerly out into the vibrant Technicolor Land of Oz. In this case, it was onto some lurid alien planet, with Captain Kirk and Mr Spock resplendent, respectively, in their char-treuse and azure tunics. It was a weird experience. Because it wasn't as if the world outside was in black and white. Reality was in colour, and, as far as my limited understanding went, it always had been.

But until a few years earlier, the visual depiction of imagined worlds – apart, perhaps, from those in paintings and in some comics – had indeed, for the most part, been in black and white. Big strides were made with Technicolor in the 1950s, sure – look at Cecil B. DeMille's Egypt or John Ford's Monument Valley – but it wasn't just a question of the process. The culture was bursting open, minds were expanding (nudged along by LSD), and it was during the next decade that things really began to change. In the transition from the album cover art of *Revolver* to that of *Sgt Pepper's* we had another Dorothy moment.

Colour was here to stay.

By the seventies, however, we were saturated in the stuff, and a new fault line had been drawn. Colour was the present; black and

Jack B. Yeats, 1871–1957
The Liffey Swim, 1923
Oil on canvas, 61 × 91 cm

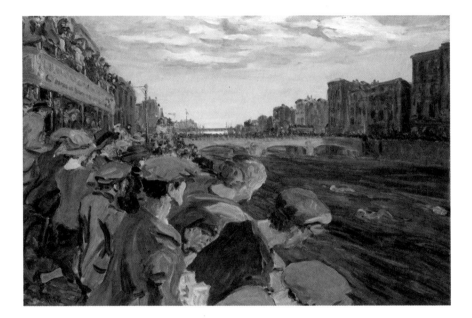

white was the past. And from that very perspective, when I turned and looked back – in time, on history – it was true: the world really did seem to be in black and white. Vietnam and Kennedy were, World War II in its entirety was, the Wall Street Crash and the Roaring Twenties were.

Ireland was.

And Dublin city most certainly was.

There were splashes of colour associated with other cities, London, Paris, New York – these glimpsed chiefly in paintings or illustrations – but Dublin, to my mind, was resolutely monochrome, dull, dreary and stilted.

Black and white.

The image I had of the Dublin that existed before my own time came from photographs and newsreels. My parents, when I was a teenager in the seventies, existed in colour – clearly (as did their clothes, and the Axminster carpet in our living room, and the Ford Cortina outside in the driveway). But when *they* were younger, getting married on a windy day in Clontarf in 1953, say, or waiting outside the Metropole, my parents – preposterously thin and gawky – existed unambiguously in black and white. When I go further back, leapfrogging from the Emergency over the virtually non-existent 1930s, to the busy, turbulent, violent 1920s *everything* is in black and white, sometimes sharply defined, sometimes blurry, a place and a time where all the men – be they rebels, priests or politicians – are wearing hats. People are uncomfortable in front of cameras, too, alienated, either posing too formally or gazing at it with suspicion. Then there are the familiar locations – street corners, buildings, monuments – but these are either deserted or half-demolished. Increasingly, this version of Dublin is defined by the Civil War – the bombardment of the Four Courts, a mass meeting in O'Connell Street, jerky footage of purposeful, uniformed men striding about the place with guns.

Beyond the photographs and newsreels, too, my impression was of an anaemic, spiritless place. Although Joyce's Dublin was from a slightly earlier time, the effect of his vision lingered.

The city was a centre of paralysis.

Of scrupulous meanness.

Agenbite of inwit.

Imagine my surprise, then, when I first came across the work of Jack B. Yeats. It wasn't in the National Gallery, either. It was on the cover of a 1971 Penguin paperback edition of *At Swim-Two-Birds* by Flann O'Brien – a writer whose Dublin has ever since been inextricably linked in my mind with Yeats's.

In a way they both did the same thing. They animated a Dublin I had never known, by infusing the city with oxygen – O'Brien's the oxygen of anarchic humour, and Yeats's the oxygen of riotous colour. *The Bus by the River* intrigued me, but it wasn't until I saw *The Liffey Swim* in the Gallery that the full impact of this hit me. Here was a vibrant, living and colourful Dublin, a city of real people who were more than just flitting figures in the background, more than just extras in a historical tableau. My grandparents were in their mid-twenties at that time, living in the city – and they could easily have been in attendance at one of the Liffey Swims, huddled along the quays there, peering in at the swimmers with their fellow Dubliners.

Yeats's early career as an illustrator and comic-strip artist, as well as the time he spent in the bustling urban centres of London, Manchester and New York, undoubtedly informed his later choices as an artist, and fed his interest in public events and public spaces. In a series of paintings he did in the 1920s, among them *A Full Tram, Dublin Newsboys* and *Lingering Sun, O'Connell Bridge,* he depicted the dynamism and colour of the modern city in a way which – for Ireland at that time, at least – was unique.

For me *The Liffey Swim* will always be a door I can push open to that time and to that world.

VONA GROARKE

Crucifixion

i.
Two keyholes line up with each other and an end wall
of gold paint. My eye is pressed to the first of them,

my back to an everyday room half-lit as if
by streetlamps through curtains mildly closed.

In the next, the century with a stone in its mouth
has acquired the language of infinite loss

and is pressing it, needle on thin-skinned metal,
to superficial gloss. In the third, wood is grained

as falling water, as static and silence framed on two sides
by a burr of ink; on two others, by what is not there.

ii.
One is the creak of tall trees, a shadow suffering.
One is a thumbprint in a knot of wood.
One is blood soaked into background, over time.
One is daylight where nails used to be.
One is to weather: to expose and to endure.

iii.
In close-up, a beam of upright wood
sways ever so narrowly, like the edge of breath,

the knowledge of centuries flocked in its flesh
and rising to the morning you swear that the blood

in your veins has turned overnight to silt, the loveliness
you'd come to think of as gold in sunlight still there,

but barely and in silhouette against the certainty
that none of it will ring as true again.

You wonder how much can be stripped away
and still be known as a life.

iv.
One is the angle of history and art
One is the straight edge of grief.
One is the crux of here and now.
One is gold with darkness in it.
One is darkness with no gold.

Patrick Graham, b. 1943; Carmel Benson, b. 1950
After Giovanni di Paolo, 1998
Drypoint on paper, 65 × 50 cm

KERRY HARDIE

Vacances

Marthe de Méligny speaks.

It is nineteen twenty three. We are blocking out the dead,
we are blocking in a world that's not at war.
There are pieces of light laid on bottles and glass,
a platter of fruits, my stretched arm.

Absence sits on the blue chair.
Everyone's holding their breath
waiting for what hasn't ended
to stand up and start up again.

Sunlight and fruit and white delph.
A striped dress, the spread of the cloth.
The darkness is held in the reach of my arms
right there, at the front of the scene,

at the front of this dance we're creating
to block out the Dance Macabre
that's rattling its bones from the trenches,
that's piling up armbands and flags.

Pierre Bonnard, 1867–1947
Le Déjeuner, 1923
Oil on canvas, 41.3 × 62.2 cm

NOËLLE HARRISON

The Return from the Market

T his is not the way home, Marguerite thinks.
The girl has her back to her. She is standing up in the boat,
so that the bow dips into the river. Marguerite clasps her hands
tightly in disapproval. This girl is willful. It must be the red hair,
just like hers had once been.

Yet she appears so demure to the outside world, meekly slipping
her arm through hers as she had guided her through the market
this morning. The past few weeks Marguerite has often been unable
to find the right words to express herself. It is unsettling and she
prefers to let the young girl speak for her.

The scent of peaches wafts up from the basket, mixed with the
weedy tang of the river, and the ripening valley in late summer. The
sun is on Marguerite's back, as comforting as a mother's hand, and
she can smell the opening up of a hot day. She would like to be back
home, on the veranda, drinking coffee.

But even there she would be measuring her regrets, counting
them out like coins. She would be waiting for the sound of her hus-
band's step, holding her breath for his approach until she is forced
to exhale, the reality of her widowhood making her sag in the chair.

No they are not going home. The girl pushes the boat forward with
one oar, directing them towards a bank dark with full-blown oak
trees. Marguerite can see a flicker of movement. She tastes a famil-
iar sourness in her mouth, dread tightening her bones. She wills the
girl to turn around, at least pause to raise her oar up high and let
the river water speckle her skin, awaken her from her trance. She
should give herself a moment to reconsider. Yet Marguerite knows
in her heart this girl will not change her mind now. She can sense
her longing in the sway of her hips as she propels the boat forwards.

John Lavery, 1856–1941
Return from Market, 1884
Oil on canvas, 117 × 61 cm

They plough through a meadow of water lilies, their waxen petals offering up golden orbs of hope, and glide upon sunlight - dappled water, a pathway back in time. Marguerite hears the frantic beat of her heart drumming inside her head. She knows what will happen next. It is the beginning of the end of this young woman's joy, and Marguerite is unable to stop her, her voice strangled inside her heaving chest. Her eyes begin to water, yet despite her blurred vision she can still see him. The artist of her life.

The boat bumps rudely against the banks, and the girl throws him the rope. Marguerite studies this young man. She has to admit he is a glory to behold: his bare forearms honey brown in their rolled up shirt sleeves, the waves of his hair as thick as thatch, and those eyes, so doleful. He always spoke with his eyes, she remembers. Her husband had been a man of few words.

The girl tumbles out of the boat and into her lover's arms. He leads her away from the riverbank for they have little time to waste.

Marguerite unhooks the basket from her arm, and stands up. She staggers across the rocking boat. It is pushed into the bank, so sticky with mud there is little need to tie it up. She climbs out, and for the first time in weeks it feels as if she is standing on firm ground. She has been floating since the day of the funeral.

Marguerite comes upon them in the glade. He is untying the girl's loose braid, so that her auburn locks spill out with flagrant abandon. The girl giggles.

You silly little fool!

Marguerite glowers with disapproval at the girl. It is no good looking at him. Nothing will stop him but maybe the girl can see her future admonishing her.

With tortuously measured movements he undoes the bow of the girl's apron, and it flutters to the grass. He kisses her.

Marguerite can feel that first kiss, his lips upon hers once again.

Oh the sweetness.

Dizzy, her legs buckle and she sits down on a large boulder. She sees it all: the blue dress unbuttoned, the red petticoat slipped off, the black stockings rolled down. Gently but with determination he pushes the girl down upon the forest floor, her nakedness framed within heather. Marguerite cannot look, and yet she must. Maybe how she remembers it is not how it was: the moment he took her virginity, the seconds within which they conceived their first child. How this hour of liberated bliss became a lifetime imprisoned. Married to a man she believed she should not love.

'No!'

Marguerite finally finds her voice.

And for a moment the girl stops kissing him, and looks over his shoulder directly into her eyes.

'What is it?' he asks her, trailing his finger down her cheek.

'I thought I heard a voice,' she says.

'It is nothing,' he reassures her. 'Just a bird.'

The girl takes the man's hand, and guides it between her legs, upon her most private self. Marguerite shivers in shock. Yet to her surprise the man lifts his hand away.

'Maybe we should wait?'

'No, now,' the girl murmurs.

So brazen!

Marguerite's cheeks flush at the memory. She drops her head and focuses on the carpet of clover at her feet. She is unable to watch their passion. It fills her with shame. All of their lives she blamed her husband for trapping her, and yet it wasn't true. She had loved him.

The couple's sighs filter through the forest, twisting upon the breeze. When Marguerite stands up again, they are gone. Yet their image is stuck fast inside her head. Yes, she nods, this is what really happened.

The girl is waiting for her in the boat. Her hand outstretched to help her in; a smile upon her face. For the first time since her widowhood Marguerite smiles back.

SEAMUS HEANEY

Banks of a Canal

Gustave Caillebotte, *c.* 1872

Say 'canal' and there's that final vowel
Towing silence with it, slowing time
To a walking pace, a path, a whitewashed gleam
Of dwellings at the skyline. World stands still.
The stunted concrete mocks the classical.
Water says, 'My place here is in dream,
In quiet good standing. Like a sleeping stream,
Come rain or sullen shine I'm peaceable.'
Stretched to the horizon, placid ploughland,
The sky not truly bright or overcast:
I know that clay, the damp and dirt of it,
The coolth along the bank, the grassy zest
Of verges, the path not narrow but still straight
Where soul could mind itself or stray beyond.

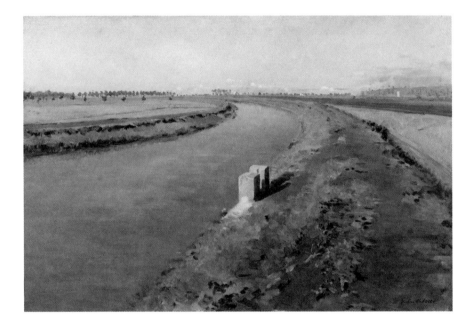

Gustave Caillebotte, 1848–1894
Banks of a Canal, near Naples, c. 1872
Oil on canvas, 39.7 × 59.7 cm

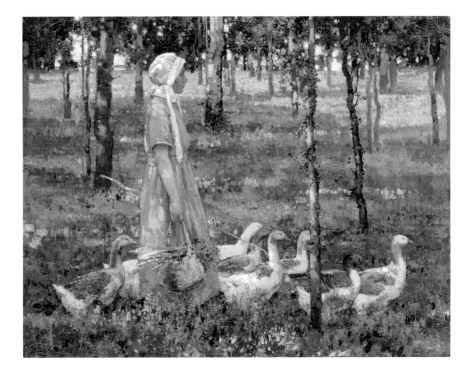

Stanley Royle, 1888–1961
The Goose Girl, c. 1921
Oil on canvas, 72 × 91 cm

CHRISTINE DWYER HICKEY

The Goose Girl

I came across the National Gallery quite by accident when I was about thirteen during a long cold spell of school absenteeism. The British call this 'playing truant', and that was the term favoured by the head nun who finally snared me in the corner of her office, snarling and hissing like an angry cat until I broke down and confessed to everything. In those days adults never asked why – you were disobedient and you were a liar and that was that. And so I had 'truant' to add to the long list of my shortcomings.

A more popular term – the one most favoured by practitioners themselves – is 'going on the hop' or even, 'going on the bounce'. Jolly phrases both, implying many splendid things such as adventure and defiance but above all else, comradeship. There is risk, yes – but with the risk comes a certain euphoria. There are no giddier schoolgirls, than schoolgirls on the bounce.

The word miching – at least, I have always felt – holds a slightly different meaning.

A micher is someone who tends to go it alone and does so on a regular – even compulsive basis. The micher wanders through cold city streets, no one with whom to share pleasure or risk; to provide company in a café or to sit alongside on a park bench. Miching is about trudging around waiting for the hours to pass. It's also about loneliness and fear. Fear of being caught, fear of going to school. Sometimes even fear of going home. In my day I was a champion micher.

My parents knew plenty of painters and as a small child I had been in artists' studios on several occasions. Harry Kernoff had painted a rather gruesome portrait of my mother. And there had been two artistic friends of my father both named Robert, who

drank in McDaid's and had a paint-splattered studio nearby, the air heavy with an exotic scent of oil and white spirits. At one point my father was even a part owner of a small gallery in Monkstown. But for some reason – and this seems strange to think now, I had never been into a gallery and I'm not sure I even knew what a gallery was.

I had seen the building from the Square of course – it was, after all, in a part of town that was ideal for my purpose – away from my usual bus route (an important consideration for the serial micher) and near to the Dental Hospital which in itself, provided a convenient excuse, should I ever be asked to supply one by a policeman or a concerned passer-by.

And so, one mist-chilled February morning, I happened to be walking along Merrion Square West when a flock of gabardined schoolgirls poured out of a coach. And I'm not sure why – perhaps it was loneliness or a sudden compulsion to belong to the herd (their gabardines were the same colour as mine) – but as they moved through the gate, I sort of tagged on.

For a while I just drifted, basking in the warmth and mellow light of this strange place with its open-ended rooms and unexpected aura of peace. Then gradually I began to notice the paintings.

At first they were just pictures – cleverly painted photographs of people and places.

I glanced at a few, began to hesitate at a few more, lingered at others, then went back to the first one and started all over again.

Time passed. From other rooms, I could hear the shuffle of schoolgirls' footsteps and a teacher's voice explaining a technique or a story about this or that painting. Here and there, the corner of my eye caught a man in a uniform standing with his back to a wall. But I no longer feared being noticed – I couldn't be noticed anyway, because now I was somewhere else: snow scenes and summer scenes; immense skies and small landscapes; cities and bridges, wild seas and soft purple hills. I had barely time to come to terms with one painting before the next one had entered and taken over my head.

There were men in long wigs on squat-looking horses; pale-faced women in dim interiors; fat babies with halos cradling their heads. A very pink female nude gazed at herself in a mirror. A child with sinister eyes gazed at me – no matter which side of the room I moved to. The woman with light coming out of her hands was the woman who served in our local shop. And that man wearing a velvet cloak and a cocked hat with feather was the poor drunken soul who sometimes ran messages for my father at the races. There were children in rags and children dressed like miniature kings and queens. There were angels and soldiers. Dogs that could bite the hand off you in a second and glint-eyed birds who would take flight if you made a sound. Everything was alive, even things that couldn't possibly be alive, like apples and wine bottles gleaming with light.

I was wandering through the rooms of a vast house, and the paintings were windows through which I could see snippets of other people's past lives, and in doing so recognize something of my own.

I found the Goose Girl that day – had it been a few years later, adolescent cynicism may well have led me to dismiss her. But that day we were made for each other.

She was alone. She was coming from somewhere and going to somewhere, but for the moment caught in this window frame. Her dress was a shapeless orange; she wore her bonnet as if to cover her face, the way I often wore my gabardine hood to cover mine. Her profile was plain and showed someone who was neither woman nor child; her nose was the size of a knuckle. How old was she? I wondered. What colour was her hair under her bonnet? What time of the day was it? And even, somewhat cheekily – why wasn't she in school?

Years later, I would get to know the rest of this picture by painting a copy of it for myself. I would feel the shape of the geese under the brush, the blots of light on the bark of the trees, the soft blue of the flowers the girl was wading through. And I would learn the story behind the painting – how it was Stanley Royle and not

William Leech who had painted it and how the true identity of the painter finally emerged. And of course I would find out who the goose girl really was.

But for now, none of this mattered. The geese were incidental. The woods and the bluebells or perhaps even lavender (I'm still not quite certain which) mere background staging. To my thirteen-year-old self, there was only the girl.

A girl moving with a slight awkward stoop – the stoop of someone who is watching her feet; measuring her steps against time.

DECLAN HUGHES

The Return of the Goats by John Lavery

This painting is not my kind of thing. I don't really do pastoral: goats, the forest, a *farmer*, for God's sake. I think of myself as more of an urban guy, an up-to-date guy, a way-we-live-now guy. But the hazy twilight-or-dawn atmosphere drew me in: the forest as a vestigial zone, a numinous border between reality and dream. Not to mention the goats. It worked its mazy charm on me. I fell under its spell. I couldn't take my eyes off it.

A painting can be like a lover; you wake up suddenly in the middle of yourself and ask: what on earth was I thinking? It catches you unawares. It appeals to some aspect of yourself you don't entirely understand or acknowledge. Thought is beside the point. Rather ask: what possessed me? What holds me still?

We'll get to the goats in due course. First, the farmer. (I can't call him a goatherd – blame Oscar Hammerstein. *The Return of the Goats* is from Lavery's French period, so I could say *berger* – in French it also means shepherd – and we'll get to that too.) The painting was made in 1884, but there's a time-slip quality to his clothes that immediately wrong-footed me, the sense of a contemporary scene painted in a nineteenth-century style, or more accurately, vice versa. You could look out a window today and see a guy like that, in an old jacket and a tweed hat.

Then there's the light. I'm not sure if it's dawn or dusk; either way, it's that soft, hazy, fragmented light that makes everything it touches seem provisional; notional, even. The mood is dreamlike; the subjects suspended in time. There's a cold glow from what looks like a lake in the background, and scrub on the floor, and the native trees are bare. The forest is its own place, and the farmer is an intruder.

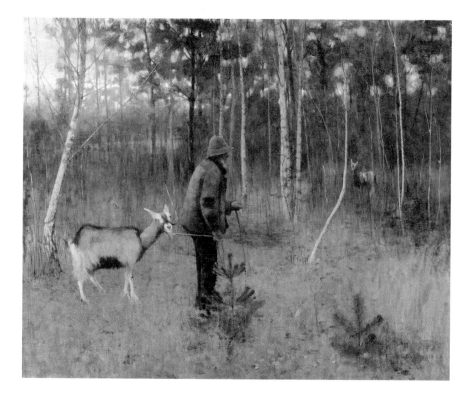

John Lavery, 1856–1941
The Return of the Goats, 1884
Oil on canvas, 81.5 × 100 cm

We're intruding too, as the tethered goat in the foreground lets us know, his level gaze weighted with alert intelligence and an aloof, almost haughty quality. *What are you looking at? What are you even doing here? It is up to me to consent to being in your charge. And I withhold that consent.*

The lust of the goat is the bounty of God.

The Marriage of Heaven and Hell – William Blake

There's something about goats, they way they seem to look right through you. Granted, these are not the heavy-horned black beasts that carry with them more than a whiff of sulphur. I met such a goat once over a five-bar gate in Aberdeenshire, hooves stamping through ice pools and plashing the frozen ooze. The encounter was vivid, reeky, primal; I felt like I was in the presence of the Devil himself, and that he could see into my soul. *Brewer's* reminds us that the goat has been associated with lust and lechery and with devil worship since earliest times, and suggests that the reason the devil was thought to have created the goat was because of the animal's destructiveness.

Of course, what goats destroy are their own fences, pens and boundaries; they always try to escape captivity, and often succeed. Maybe rebelliousness is the better word.

Escaping goats, scapegoats, rebel angels. As part of the ritual for the Day of Atonement, two goats were brought to the altar and the high priest – perhaps we should say *berger* now? – cast lots, one for the Lord, one for Azazel, standard-bearer of the rebel angels cast out of heaven. The Lord's goat was sacrificed, and the scapegoat, now burdened with everyone's sins, was let escape into the wilderness. Into the woods. Once free, like cats, goats quickly revert to a wild state. Domesticity and dependence are lightly worn. Consent is easily withdrawn. *Non serviam.*

What if the tethered goat in our picture is the only one to be returned (where return means death); the other is not being beckoned, but banished (where banishment means freedom). And even then, she bridles, willing the shepherd on, luring him further and further from the light until he is quite lost.

Is this what the artist intended? Probably not. But the artist's intentions are none of our business. (If he knows what's good for him, they're none of his business either.)

At dawn, or at twilight, in a forest clearing by a lake, memories and myth collide, a classical allusion is implied, or inferred, and two goats are returned, or return themselves, to death or to exile, as man, that bewildered old intruder, is stranded, eternally, between deliverance and oblivion.

JENNIFER JOHNSTON

Le Déjeuner

Bonnard fills me not exactly with joy, but with the joyous recollections of times in my godmother's house, which stood on its own little hill way out beyond Rathfarnham, but not quite as far as the Pine Forest. All of Dublin was spread out for visitors to admire as they stood on the steps that led up to the front door. Day or night, rain or shine, it was a view for all seasons. It wasn't a big Big House but it had an authority of its own, a symmetrical gem, yellow and splendid on its hill, poised above the capital city.

Each mealtime had its own personality; breakfast, people came and went, ate in silence, rattled the newspapers, opened letters, muttered about their day's plans. Dinner had its particular formality, polished silver, dishes handed round by maids, a certain tidiness of dress, cheerful general chat, no hanging about as the maids would be raring to go to whatever dance was nearest, their bikes and their boyfriends waiting at the top of the avenue. Mrs Cooke, who really was the cook, saw to it that the kitchen was tidy and that the breakfast table was laid in the dining room before the girls put one foot out of the house. Lunch though always seemed to be a lazy meal, full of chat, chat, chat. There was always something to chat about; a new play, torn to shreds, by the caustic wit of whatever visitor might have seen it, a film, gossip, the dreadful politicians, racing, yet more gossip, would we swim, play tennis? There was always someone to say that you must not swim for an hour after meals, groans and laughter. There were rows and reconciliations. We ate grapes and delicious peaches from the greenhouse. The lord's pride and joy, those peaches were. Before he caught the bus to work in the morning he would go to the greenhouse to admire and count his peaches. Woe and betide the world if the expected number was not

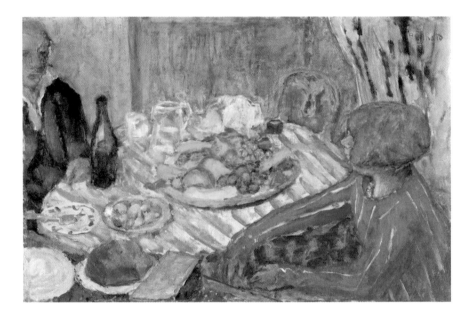

Pierre Bonnard, 1867–1947
Le Déjeuner, 1923
Oil on canvas, 41.3 × 62.2 cm

there; he would then stride down the avenue wearing his Homburg hat and swinging his briefcase. When he came in view of the village the cry would go up 'The lord is coming!' The bus driver would put out his cigarette, settle himself into his seat and start up the engine, all ready to go…All in his lordship's good time.

Tea was, whenever possible, served in the garden, that meant when the sun was shining. The garden furniture was painted bright blue and the chairs scattered with cushions. The Muscovy ducks, alerted by the gathering of humans, would peck their way through the legs of tables and chairs, until one of them, bold as brass would fly up onto the table and begin to eat the cake. This would become too much for her ladyship who would strike out at the birds with her parasol and shout for brave people to herd them back to the farmyard. No one enjoyed this task, as the ducks didn't want to go back to the farmyard, nor were they as frightened of human beings as we human beings were of them. Anyway, they almost always reappeared about half an hour later waddling gracelessly across the grass, pecking as they came. They were the victors. In the end they got their cake.

The first of Bonnard's paintings that I met (I do meet paintings that I like a lot and we speak silently to each other) was of the end of a meal – a long table, scattered dishes and people, empty bottles, a languid air, summer sun and behind a yellow house rises up. No Muscovy ducks to be seen but it was indubitably Rockbrook. I have loved this painter ever since; no posing in his paintings, things are rumpled, intimate, and the light is real and the food is good and the chat has been good. There is nothing false. The goodwill is enormous. Perhaps that is why I enjoy my conversations with Bonnard's paintings so much.

THOMAS KILROY

James Arthur O'Connor, *Ballinrobe House*

To stand in the same position today, more or less, as James Arthur O'Connor did with his sketchbook, nearly two hundred years ago, is to see this picture with a double vision. The scene before the eye both is, and is not, the image of the painting.

O'Connor came to the west of Ireland when commissioned by Lord Sligo to execute a series of paintings associated with his splendid home, Westport House. The Kennys, a Huguenot milling family of Ballinrobe, got the same idea and had O'Connor complete a series of landscapes for them; three of Ballinrobe and one of the nearby Lough Mask. The focus of these Ballinrobe paintings was the Kennys' house, now sadly boarded up, a victim of the ravages of the times that we live in.

The artist, then in his mid-twenties, stood somewhere just off the present Bower's Walk in the town looking back towards the Kenny House and Mill across the water and the bridge. Although time has brought a number of significant changes to the scene it is still remarkable how much O'Connor himself erased. In all three Ballinrobe paintings there is a discreet de-emphasis of the town itself, except for those buildings deemed particularly important. This was integral to O'Connor's Romanticism. O'Connor sought to escape his difficult, unhappy life by withdrawing into pure land-scapes – landscapes untouched by the harsh realities of ordinary life. Nature, in these Ballinrobe landscapes, is benign and beautifully conveyed in a delicate style. In his later paintings O'Connor would turn to a darker, more turbulent, gothic version of Nature.

Here, O'Connor wanted to convey a pristine scene but one in which human habitation still had a place. It is a celebration both

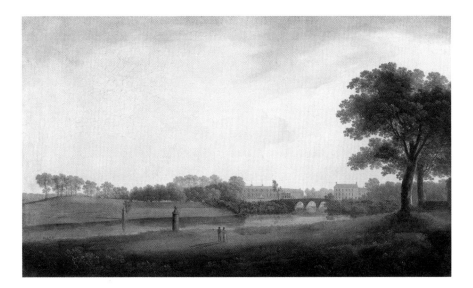

James Arthur O'Connor, 1792 –1841
Ballinrobe House, *c.* 1818
Oil on canvas, 42 × 71 cm

of Nature's loveliness and of human wealth and power. So, we have the carefully selected buildings; the Kenny home, the miller's house, the mills and, almost out of sight, the top of the Infantry Barracks just visible, off centre, through the trees. In other words, Nature displayed in front of commercial and political power. This summed up the conditions under which artists produced commissioned landscape paintings during the eighteenth and early nineteenth centuries, particularly those connected with great houses.

Laid out between the sketching artist and the house is the landscape, the heart of the painting. But even in this landscape there is human calculation. There is only an *appearance* of natural freedom. The Kennys, like many owners of such grand houses, employed gardeners to lay out large landscapes with the same level of ambition and attention as they would apply to gardens of a more modest size. This is what we have here, in what were known as the 'Pleasure Grounds'. Indeed, Mrs Kenny even had her own underground access to these lovely waterside walks.

Today the people of Ballinrobe and its visitors, including myself, enjoy much the same scene as Mrs Kenny did, but I often think upon the changes that have taken place since her time. For one thing the river has been moved. The limpid expanse of flow shown in the painting has been narrowed to a deeper rush between stone banks, which once served as a towpath and is now a lovely walk today. This engineering of the river was part of a canalizing process carried out later in the nineteenth century. The idea was to develop a waterway system of traffic in the west of Ireland, through canals; something that died with the development of the railways. The two strange pillars in the painting are gone. Were these just other ornaments of the Pleasure Grounds, human markers set down to suggest the possession and control of Nature?

What about the human figures in the painting, one of whom leans upon a staff? They are obviously enjoying the Pleasure Grounds and have stopped for a chat. Technically, the human figure was used to add a sense of scale to a landscape painting, a degree of

measurement. But the use of human figures also invites narrative, and hints at a story being told. Who are these people? Where have they come from and where are they going? O'Connor's two figures are paused and passive. This suggestion of suspended activity adds to the stillness of the scene. It is as if a fragile beauty has been caught, briefly, in a moment that will soon pass. Perhaps they stand for us, as we look at the painting, side by side, in silence?

MICHAEL LONGLEY

Paintings

I

Gerard Dillon painted the blinds in his two-up,
Two-down house in Clonard Street – Irish saints,
Farm animals, Connemara dreams – so that
At evening when the gas lights were lit and
The blinds drawn, children from the Lower Falls
Would gather to gaze at a magic lantern.

II

Dillon found two wells on Inishlacken,
One cup-sized in a rock, seaweed-thatched,
One at low tide, sandy drinking water,

III

He painted the island like a seabird's nest.

Gerard Dillon, 1916–1971
The Little Green Fields, c. 1946–50
Oil on canvas, 40.5 × 89 cm

MARTIN MALONE

Before the Start

There are times when he's not in my thoughts and then I see or hear something and I think, 'Dad would like that', and the abrupt realization cuts like a knife through my heart: he is not around to share 'that' something with – that the time for sharing has passed us by. I expect it is like that for a lot of people who have lost a parent, a wife, partner, a child…in the process of living a stone-cold reality is occasionally lost to you. Perhaps this is a blessing?

It was on a Monday in July when I went with Dad to Dublin on the Arrow train. He had an appointment at the Dental Hospital outside the gates of Trinity College. He was fighting to save the last of his teeth. Throat and soft palate cancer had been tearing at the fabric of his existence for sixteen years and while it had affected the quality of his life, he had a life.

We had time to burn and I suggested a visit to the National Gallery, just a few strides across the road from the hospital – he didn't know this, which tells you of his interest in art.

There were paintings at home, of course, but mostly photographs adorned the walls. The paintings were of a castle on a lake (slightly torn at one corner), an old picture that had once hung in the Stand House at the Curragh Racecourse, a gift – as was another that I had brought back from Iraq in 1989, depicting a Bedouin camp.

He looked at me and nodded and said, 'Why not?'

Dad liked to talk. After he was talking for a while his words lost their clarity and he forgot that people couldn't understand what he was saying – he kept on spilling those incoherent sentences until realization set in, and then he'd nod somewhat in dismay and emit a deep sigh borne out of sheer frustration.

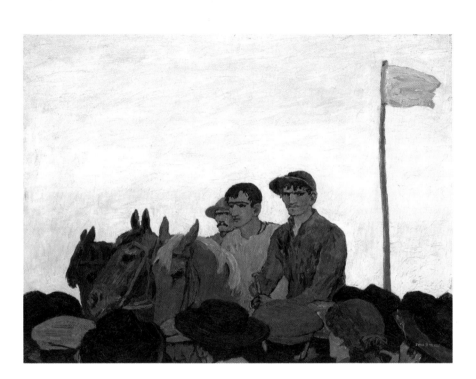

Jack B. Yeats, 1871–1957
Before the Start, 1915
Oil on canvas, 46 × 61 cm

He was a horseman, a jockey, a stable-yard foreman. He loved horses and animals and had enjoyed a lifelong association with race-horses. An outdoor man, not one for art galleries or museums with their high ceilings and long walls hung heavy with paintings.

I had been seconded by my mother to accompany him to Dublin. She was his usual companion to the city, his voice when his grew tired. However, she had her own hospital appointment that day in another part of the city. Not to wound his pride I said I'd accompany him, on the pretence that I had to meet someone in Trinity. He had failed a lot in himself and had not known a pain-free day in those sixteen years.

So we stepped inside the National Gallery and walked along the corridor, climbed the steps, not paying much heed to the sculptures. The paintings, ah – these drew him in – images of yesteryear caught by the skill and sure vision of the artist's eye; a military parade, a market scene, nudes in recline, bewigged gentlemen and gowned ladies...dray horses, racehorses, ponies, overhanging tree branches sweeping still rivers, moonlit skies, a knight and his mistress on a spiral stairwell, a sun splashing orange on a distant horizon, men forking seaweed onto a cart while a blinkered horse stands steadily by. And of course a race meeting by Yeats, which reminded him of summer trips to the Galway Races.

He kept his hands in his jacket pockets and read the inscriptions, the year the paintings were completed, donated by, purchased from and so on. And it wasn't a place for talking, at least not aloud. There's a natural hush, not unlike that to be found in a church, in the art gallery. A reverence, as though the visitors were inherently respectful of the soul caught on canvas.

We delayed longer than intended and got lost on the way out. Both of us blessed with a poor sense of direction. Believe me, an arrow isn't adequate enough direction for some people. Outside, he welcomed the cool air blowing against his face.

'Did you enjoy that?' I said.

He nodded and said, 'It was something new.'

Better than he thought it would be, perhaps – this visit to an unfamiliar world?

I left him at the hospital. He would be in and out, he said, just a checkup. I headed on in to Trinity College to kill time and met Brendan Kennelly sitting on a bench enjoying a rare spell of sunshine. We spoke for a few minutes and then mindful of Dad's in and out, I went back to the hospital. His 'in and out' took three hours and when he emerged he was obviously in considerable pain and discomfort. But at home he didn't tell my mother of what the dentist said or what procedure had been done – he never complained – he just talked about the Gallery until his words grew tired and we could no longer understand what he was saying.

AOIFE MANNIX

Launching the Currach

Men in white shirts and caps,
arms stretched with the weight
of black. The shadow
of a boat glistens
on sand as the tide
rolls out. The wild waves
of the Atlantic
churning wet and cold.
The water a blue
as dark as drowning.
For the fishermen
never learned to swim.
Better to sink in
her arms than struggle
for hours in harsh storms
that have no known cure.

They turn their backs on
the sanctuary
of dry land. Hide faces
from the trap of soul
stealing paint. Their eyes
are salt stung and wet
as they must reflect
the hundred thousand
colours of the sea.
Her brush they have felt
many times out there
alone when the stroke
of death threatened
to wipe their figure
from this vast canvas.

Paul Henry, 1876–1958
Launching the Currach, 1910–11
Oil on canvas, 41 × 60 cm

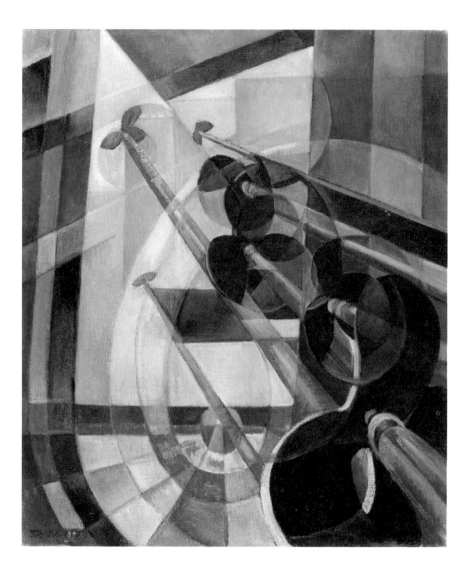

Mary Swanzy, 1882–1978
Propellers, 1942
Oil on canvas, 53.5 × 45.5 cm

COLUM McCANN

Propellers

I t was yet another war. In yet another place.

The men had gone from the country. The women piled into the factory. They had the whole human machinery at their disposal. The apparatus of kill. Every nut and bolt that held savagery together.

The women laboured. They had iron. They had chains. They had oil. They had pistons. They had rotors. They had wrenches. They had hammers. They had wheels.

But late at night, when the machinery of war was done, and the propellers were sent off to their men, the women remained behind in the factory, creating the thing that might one day fly: a secret longing for colour.

James Barry, 1741–1806
Self-Portrait as Timanthes, c. 1780–1803
Oil on canvas, 76 × 63 cm

THOMAS McCARTHY

James Barry, *Self-Portrait as Timanthes*

All through the 1990s each train journey I made became a pilgrimage to this one painting. I visited Dublin regularly to attend board meetings of Poetry Ireland, a national organization that was then expanding its influence under its revolutionary director, the poet Theo Dorgan. I always tried to arrive at Heuston Station well ahead of our meetings because I needed to commune with that other innovative native of Water Lane, Cork, the artist James Barry. Each time, I ran straight through the door of the National Gallery, then left...left again...and there it was, in all its orchestral, romantic glory, one of the most naked self-portraits ever imagined by an Irish genius. Here is art as European as anything by Jacques-Louis David and as vulnerable as anything by James Joyce. The shocked and haunted eyes of the mythical and elusive painter Timanthes interrogated me and found me wanting. None of us could ever measure up to the ambitions of Barry; none of us could ever answer such yearning from this furtive agent of the Enlightenment. Here, the artist stands back, rudely interrupted by our ignorant presence, holding an oil of the gods, at the feet of Hercules who tramples the serpent of Envy. This is not the smooth Barry with Paine and Lefèvre, painted in *c.* 1767, or the Barry seated beneath the heroes of his great Royal Society of Arts wall painting, *Crowning the Victors at Olympia*, from 1777–84. This is a mythic and dramatically self-aware Barry; this is the self-aggrandizing artist, the allegorical creator who has suffered for us.

We must all stand back from this work and feel ashamed that we have not done more for art and truth. Scholars have construed the loosened black ribbon at Barry's neck as the shadow of the guillotine, the fate that awaits all counter-revolutionaries. I beg to

disagree: I've never bought that. Surely, it is art unbuttoned, bind-ings loosened, the breath of life upon an exposed neck. The head of Envy's serpent barks like a dog against Barry's/Timanthes's right ear, but the artist's eyes appeal to us not to heed this voice of Envy, but to accept Pan's pipes and the timeless offering of the Greek landscape. Barry took his Hercules and his Envy from a reading of Horace, but the extraordinary juxtaposition of antiquity and infor-mality, of Art within art and of the troubled Corkman himself as a mythical character, is pure Barry – the product of a desperate pro-vincial auto-didact. Hercules would triumph over Envy by dying, as Barry triumphed over orthodoxy by suffering various kinds of expulsion. Explaining himself, Barry wrote 'envy should continu-ally haunt and persecute the greatest characters; though for the time, it may give them uneasiness, yet it tends on the one hand to make them more perfect, by obliging them to weed out whatever may be faulty…'

Nothing painted by James Barry was ever flawless – his drawing of hands is always poor – yet every oil of his contained more ambig-uous brilliance and politics than anything by Reynolds or Fuseli. (See! Just a few minutes with Barry and I am making aggressive and unsupported observations!) He conversed only in extremities and his ambitions for British art were unhinged by the breadth of his vision. He was an Irishman, yet he wanted the best for the English mind. His London efforts to extract the best from British possi-bilities would destroy him mentally and vocationally. This is the portrait of an artist who has suffered from an extreme ambition. The eyes tell us that he has been painted into a corner. Here, the artist as a cornered Timanthes marks a point of irreversible decline in the fortunes of the painter. Despite the exceptional kindness of friends in the Royal Society of Arts, Barry would isolate himself and retreat down the Thames to Greenwich, into a house with broken windows and darkened printing presses.

Nearly a decade has passed since we all stood around the plaque in the crypt of St Paul's Cathedral in London to commemorate the bicentenary of Barry's death. Now, the scholar William Presley's words are ringing in my ears: his belief that Barry's huge wall paintings in the Royal Society's Great Room are actually a piece of sustained Roman Catholic propaganda: *Great art forces us to grapple with its content, rather than merely look and say 'oh' and move on.* But I'm not sure if it matters, or let me put it another way: it doesn't matter to me. I'm never too worried about what art means; I've always been more conscious of what it *does* to me, what it says in a human way. I'm constantly saying 'oh' and refusing to move on. A poet could be saturated with Barry; I mean, any poet could come away dripping with history and historic associations. But that would be to miss the point, and the power, of this great painting of Timanthes. This is a deeply personal work of art; it is full of yearning and human wariness. It is very much the metaphor for an artistic life of any kind. And it doesn't have a citizenship or a religion: we are all hunted, as Timanthes was, and we are all nervously awaiting our destiny, as Barry constantly was. I feel for him and I feel for this painting because I know his luck ran out several times. I still love to come upon it. It speaks to me of many lost connections and that foolish yearning to hurry up and finish some all-consuming work of art.

This painting is one of the gems in our National Gallery. It is worth taking any long journey to come upon this triumph of antiquity and revolution, of political camouflage and artistic nakedness. When I stand by this painting my resolve as a poet stiffens and my political faith in the artistic life is restored completely.

The Director of Sunlight

He painted this a hundred years ago,
A third son, mother a teacher of dance,
Who met Saurin Elizabeth in a maritime parish,
A region untouched, sprinkled with white caps.
It is not an altarpiece, of peasants adorning
Luxurious walls, but a 'Plage des Dames',
A corner, maybe of an orchard, of plums,
The garden in which he recovered from typhoid.

Exhibited as 'Lilies', or 'Lady with Trees',
It failed to sell, for its unrestful, decorative
Qualities, its illusion too easily obtained.
For fifty years he was never to have a one-man show.
It could be 'Bean ag Leamh', 'Woman Reading',
Or 'The Novice'. He had the bridal wear specially
Made, for his bride-to-be, his mistress
In a nun's habit, yet to become divorced.

She wears a starched lace headdress
With a band around the front, peaked at the back.
Her gown looks flimsy under the wide sleeves
Of the top wrap's pure ripples.
She has to endure her heavy stiffened
Overskirt in intense heat, not raw sun,
But an even glow on her tanned neck,
Her youthfulness.

To say how old she is, in the rich fertility
Of that green moment, romantic figure
With forest depths all about it,
An encircled glade, an exceptionally balmy evening:
A girl called Space, who graced the rest
Of my morning, and is enough to carry me
To a new use of the mind, even if all
The supernatural stuff turns out to be wrong.

So why is he posing his favourite model
In a tinsel scarf, standing to the right,
Framing her dark locks by her bonnet,
Serenely in profile, or at prayer?
With her proud bearing and erect head
She seems to have just paused, inclines her face
To the viewer in exquisite calm,
As of something slipping, yet indelible.

He has eliminated the skyline, as if
He has cut a hedge down, you can see,
Even in winter, the open mesh pattern
Of the lace, the flower in the side of her hair.
She leans across as if listening
To unseen company, appears to grow
From the ground in a most perfect way
With a balance no plant could show.

Thin stems of fine leaves and half-shades
Of cyclamen animate the instant,
Set thickly in summer, almost hypnotically
Awash with lavender, tall, upright, fully-budded.
Petal heads curve like the strokes of grass
Behind, mingle and absorb against
The sun-dried lawn, stripe against
The smoother grasses lying underneath.

Daisies thrusting in at the bottom
Of the painting take up the mauve tone
In a simple arrangement, bathing
And winding through the yellow green.
He leads the eye through branches jutting
Out and the sunlight which alights
To an enclosed background of open
Airiness and conversational hedges:

A wild road where Sisters of the Holy Ghost
Formal in their pose and mood
Are following their quiet life,
Their feet firmly planted, but all
Swinging round like the spokes
Of a great wheel, detached by far
Shadows in a cavelike effect. If scrutinized
Too closely they would melt into darkness,

Fingering their beads, their clothes flowing
In definition in the blur.
He sees them all as one and draws them
As a position of the earth.
We are not intruders, though part of a private
Scene, a picture lovely to the sense
Yet of a certain coldness, as though
She were already passing out of view

With her questioning gaze momentarily
Off-guard or withdrawn, arrested,
Trying to evolve her reflections – it is
Possible, she decorated the frame
Before the failure of their seven-year marriage.
He said 'It looks as if the Dublin people
Have all the Leeches they want just now.
I would prefer to send you my nude

Of the black woman, instead of that
Blown up watercolour in the National Gallery.'
Nevertheless, it is interesting to contemplate
A tangled bank, however unorchestrated.
He fell off West Clandon railway bridge,
Or let himself go, as the morning train
Was pulling out in his direction
And lapsed into fitful sleep

Where our so-called perpendicular lines
Meet in the centre of the earth
Like Mercury-women, in their Merry Widow
Hats, on the mellow-splattered platform.
We all know the garden, the radiant
Immortal garden, unfinished,
Its burnt soil withered by the railroads
At each end of the same street,

Where every house reminds its neighbour,
I have been everywhere I was as a child.
It was such clearings in the wood of confusion
From which Paris scented itself with perfume
When, in August, lavender was cried
By the deadmongers' waggons
Anxious to save time like bees
After the war burgeoned.

With acknowledgments to Denise Ferran.

William Leech, 1881–1968
A Convent Garden, Brittany, c. 1913
Oil on canvas, 132 × 106 cm

A White Horse

After Géricault

For years I dreamt a white horse
Came to me from dreams
And took me against my will
To where I've always been.

A white horse for years I dreamt
Answered to a name,
And should I ever say it loud,
My life would stay the same.

I dreamt a white horse for years
Demanded the world know
When it rained – it always rained –
Its fleece would turn to snow.

For years I dreamt a white horse
Knew me well by name.
For years I dreamt a white horse
And myself were the same.

For years I dreamt a white horse
Was all there was to know.
For years I dreamt a white horse
Grew fleece as black as snow.

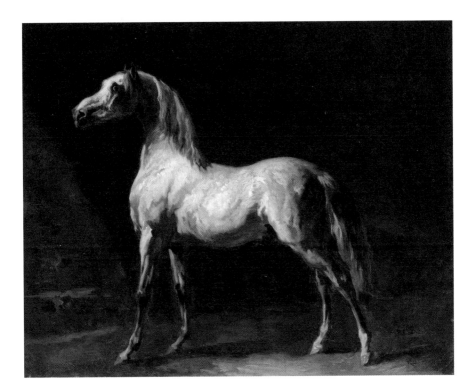

After Théodore Géricault, 1791–1824
A Horse, early 19th century
Oil on canvas, 66 × 82 cm

EOIN McNAMEE

Magdalene. Alice Maher

I t's an etching on paper of long hair. There's a coppery hue to it. It could be a woman's head seen from behind or from the front if she were kneeling, her hair falling forward over her face.

It could be a woman's hair grown down to her feet. In medieval legend Mary Magdalene did penance for sensual pleasure for thirty years, naked and destitute in a cave with only her miraculously grown hair to cover her nakedness.

Each strand carries the lyric weight of the whole.

Alice Maher's *Magdalene* is described as being influenced by Gherarducci's *Magdalene.* The Gherarducci painting shows the saint being lifted towards heaven by four angels to receive a ration of grace. The saint's face is lean and sinuous. The angels look sombre.

When my wife was in first year at art college in Belfast, she and her friend would slip upstairs to the drawing room and push the door open a crack so that they could watch Alice as she worked.

It looks as though a face is going to appear out from under the hair and say something bold just for the sake of it or tip you a saucy wink.

The image is solemn, canonical, occult. It refers to the meaning of hair, the rituals of it.

It looks as though the hair conceals a hitherto unknown sexual organ. Salty, fronded.

Mary Magdalene was so called either from Magdala near Tiberias, or possibly from the Talmudic expression meaning 'curling women's hair' which the Talmud explains as of an adulteress.

It reminds you of those Ronald Searle drawings of impish school-girls, all tangled hair and rolled-down socks, no better than they should be. The Magdala of St Trinians.

August 2007. Alice Maher goes down on one knee to tie a child's lace. She bends her head forward. Her hair falls over her face.

Product Name: Brazilian Virgin Hair, Body Wave 12 Inch to 20 Inch, new with tag (DHL Free Shipping). Length: 12 Inch, 14 Inch, 16 Inch. Color: #1B (Natural Black). The #1B (Natural Black) is the default color. Weight: About 100g/pc, about 3.5 oz per bundle.

It is the high-quality hairs, 100% Human Hair, Soft and Tangle Free, Brazilian Virgin Remy Hair.

Buy hair on eBay soft and tangle free.

You feel as if you could reach out and place your hand on top of it and feel the warmth, the head underneath, the eggshell feel of a child's skull.

It could be someone with her back to you, holding her breath. It could be someone white with anger with long red fingernails. It could be a head bent over a grave. It could be one of the possessed. It could be someone at a mirror. It could be a child in hiding. It could be an empress. It could be a laundress. It could be the fearful, the beloved, the long dead, the yet to be. It is the high-quality hairs.

Soft and tangle free.

It could be the back of two girls' heads in a college doorway peering through a crack at the back of a woman's head bent over a sheet of paper barely daring to breathe in case she would know they were there, kneeling in the cold, watching Alice draw.

Alice Maher, b. 1956
Magdalene, 1998
Etching on paper, 66 × 50 cm

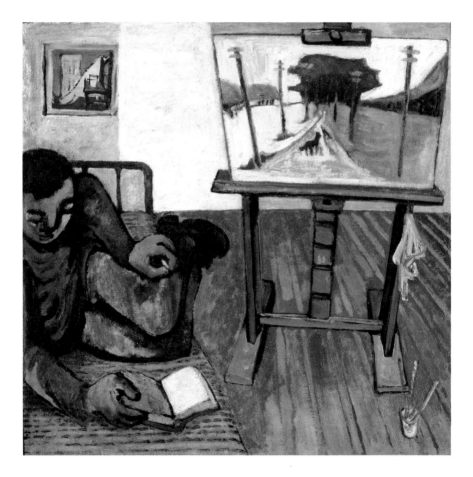

Gerard Dillon, 1916–1971
The Artist's Studio, Abbey Road, 1940s
Oil on canvas, 64.8 × 67.3 cm

PAULA MEEHAN

Artist's Studio, Abbey Road

My Trinities – three paintings in one frame:
the then, the now, the might have been, the line
between the father, the son, my holy ghosts
of all the lost and broken ones. I've made
of Dresden, Hiroshima, the bitter news
that beats down with the February rain,
a man, a book, an hour of blessed peace.

As surely as I know the rain will cease
I know there was an end to mortal pain
for the communists, the gypsies and the Jews,
for all damned as *other*. For fear they'd fade
from memory like their murderers' boasts,
I dedicate my freedom in this sign,
a shrine to peace, erected in their name.

The Unfinished Painting

Last night I saw the painting in a dream
and though I was not in the picture plane
I was just offside, shackled foot to wrist.
A red fox crossed my path from field to wood,
a heavy snowfall dampened down the shunt
of camp bound trains, the prisoners' hungry caoin.
The red fox looked me squarely in the eyes

to reassure me vision never dies
if rooted in truth. So paint what you mean
about *snow tree path*; and mean what you paint.
Though underneath the snow there's the shed blood
of those whose names I read from this sad list,
and from the forest echo howls of pain,
I trust the path I'm painting leads me home.

Domestic Interior

Of all the seasons in this basement room
it was yours I loved. Not that I let on:
in Belfast style I said you weren't the worst.
I curl up in the hollow of our bed –
your shirt's abandoned on the chair, your shoes
and socks lie like snoozing pets among the ruin
of our days. You were my sun, my moon, my stars.

And in truth you still are despite our wars.
I'll never take your holy name in vain.
If bigots kneeling in their shiny pews
should call the law down about your head
or if by your friends and family you be cursed,
I'll stand by you – heart to heart, man to man –
the yellow door secured against their doom.

JOHN MONTAGUE

El Greco's *St Francis Receiving the Stigmata*

My task here is to discover a poem within a poem, like the ravenous pike I once caught on a midland lake, with a perch nestled inside its stomach.

As a student, I haunted the National Gallery, all the more since I had begun to attend the marvellous evening art lectures of Françoise Henry. And again and again I returned to the elongated, ecstatic figure of *St Francis Receiving the Stigmata*, the opposite of those homely, tender images of him preaching to birds and animals, one of which had adorned my bedroom in Garvaghey. That was my childhood; this was my feverish adolescence.

Meanwhile I was reading Françoise Henry on early Irish art, and longed to see the *clochans* of the West. So I superimposed this longing on the ectoplasm of El Greco's St Francis, to produce a poem called 'A Footnote on Monasticism', which appears in *Forms of Exile* (1958). But my real St Francis poem hides in the less discursive stanzas, which I now place together, on their own, for the first time:

See, among darkening rocks he prayed,
Whose body was chastened and absurd,
An earth-bound dragging space in which
His seeking spirit blundered like a bird:
Whose hands, specialised by prayer,
Shone like uplifted chalices,
Nightly proffering the weight of self
To soundless, perfect messengers.

In ceaseless labour of the spirit,
Isolate, unblessed;
Until quietude of the senses
Announces presence of a guest;
Desolation final,
Rock within and rock without
Till from the stubborn rock of the heart,
The purifying waters spurt.

1953

El Greco, 1541–1614
St Francis Receiving the Stigmata, 1590–95
Oil on canvas, 114 × 104 cm

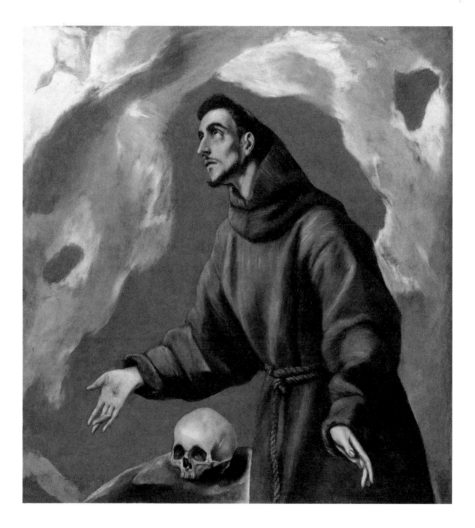

PAUL MULDOON

Charles Emile Jacque: *Poultry Among Trees*

It was in Eglish that my father kept the shop
jam-packed with Inglis loaves, butter,
Fray Bentos corned beef, Omo, Daz, Beechams powders,
Andrews Liver Salts, Halls cough drops,

where I wheezed longingly from my goose-downed truckle
at a Paris bun's sugared top.
A tiny bell rang sweetly. The word on the tip
of my tongue was "honeysuckle".

When one of his deep litter chickens filled its crop
with hay from the adjoining shed
my father opened it with a razor blade, reached
in, pulled out the shimmering sop,

then sewed it up with a darning needle and thread.
That childhood memory came back
now a fracas had left two hens with gaping beaks,
one with what seemed a severed head.

Though I might have taken the blueprint of a shack
from *Poultry Keeping for Dummies*,
I'd fancied myself more an Ovid in Tomis –
determined to wing it, to tack

together Jhangiri Mahal from a jumble
of 2 × 4 studs, malachite,
run-of-the-mill planks, cedar shingles, more off-cuts
in New Jersey's rough and tumble.

Now it looked as if there had been a pillow fight
in and around the chicken run.
Our pointer, Sherlock, had instigated a reign
of terror, scaring the daylights

out of the hens (in a spirit of good clean fun,
no doubt), launching a morning raid
such as Meleager & Co. had launched to root
out the great boar of Calydon.

Their temperature being 106 centigrade
might account for the quizzical
view chickens take of history going in cycles,
but I could divine from the jade

of her exposed neck, the movement of her gizzard
jewelled by broken oyster shells,
one hen had ventured so far on the gravel shoals
she'd become less hen than lizard.

As the echoes of Sherlock's high-pitched rebel yells
clung to the thatch in a smoke-knot,
I'd only very gradually taken note
how Herbert Hoover's casting spells

(and offering that "chicken in every pot")
had come too late for Robert Frost,
cooped up as he'd been on the edge of a forest
with some 300 Wyandottes.

Odd that the less obviously wounded hen be lost
to the great realm of the cageless
while a slash-throat somehow lingers. Though I cudgeled
my brains, the only thought that crossed

my mind was how the sisters of Meleager
had once morphed into guinea hens.
I found myself looking to Aries, the heinous
Dog Star, then to Ursa Major.

Those next few days, the slash-throat held out a quill pen
with which we might together draw
up a plan on how I could help her muddle through.
Her comb and wattles were cayenne

under a heat lamp. Her throat left my own throat raw.
She lifted her head on its latch.
It was as if a sop of hay had become lodged
in my own mother-of-pearled craw.

The ears of barley, whole wheat and corn mixed from scratch
I boiled down further. My new razor
had me on edge. I was such an early riser
I'd become less man than rooster. An extra batch

of the barley/wheat/corn mush might help her brazen
it out. Till she could shake a leg
(and a wing!), I'd feed her the stuff I myself like –
marigolds, cottage cheese, raisins.

Though Fabergé's first inlaying a gilt hen egg
was by imperial decree
it's easy to see why we dunghill roosters crow
when we set off a powder keg

at our own behest, winding ourselves with a key
till our workaday art's a match
for workaday life, a feature rarely as much
to the fore as in *Poultry Among Trees.*

Here the angle of the ridgepole (though blurred by thatch),
leads the eye to an odd focal
point where two hen harriers confirm how fickle
is our grasp on things. If a patched

chicken did once attest to his skill in sewing,
my father still boned up in full
on "how to remove the merry-thought of a fowl"
from *One Thousand Things Worth Knowing.*

Even if I have helped my own hen to pull
through by dint of mash and mush-talk
I'm still far less disposed to look to the sky-dog
for assent, or to the sky-bull,

to look to any of those old cocks-of-the-walk.
Not for me strutting out at dusk
and pretending to be equal to any task
while sporting a cayenne Mohawk.

Once I glimpsed the ideal under a dry husk.
All I see now is the foible
in a sword. I often think of Aesop's fable
where a great boar sharpens his tusk

against all likelihood. Now being a goitered
rooster is all that's on the cards
for me, I suspect, consigned to the pile of grit
I myself once reconnoitered.

I was a Rhode Island Red rooster standing guard
in Eglish as my father sliced.
"Think like a man of action," wrote Mr Sallust,
"act like a man of thought." The yard

opened on my less-than-steady Peter, then Christ,
then the rum-numbed hen, then the nail
from which it hung. As an emblem of renewal,
surely that hen would have sufficed?

My own new regimen of cottage cheese and kale
continues to help me toughen
my resolve in ways Sherlock himself might divine.
The elongation of his tail

has been traced to a long line of partridge-flushers
and catchers of hares on the hop.
I don't mind being relegated to the heap
where I once stood as both door and usher.

For I've no aspirations now ever to strop
my beak on the bark of a church.
Ever to be a weather vane… To be in charge…
That's for a motorcycle cop,

all Ray Bans and chrome, so ill-at-ease on the perch
of a fire escape in a flop-
house in west L.A., the downy feathers he'll flip
through in a routine background search.

Now my right-as-rain hen, like my father's post-op
hen, will shine out from her dunghill.
That sweet little bell… I recognize its tinkle…
Another customer who'll drop

by for Bisto, Bovril, Colman's English Mustard,
Liquorice Allsorts, lollipops,
Warhorse plug tobacco, Gillette razors, Bo-Peeps,
Chivers Jelly or Bird's Custard.

Charles Emile Jacque, 1813 –1894
Poultry among Trees, c. 1860 – 80
Oil on panel, 27 × 45 cm

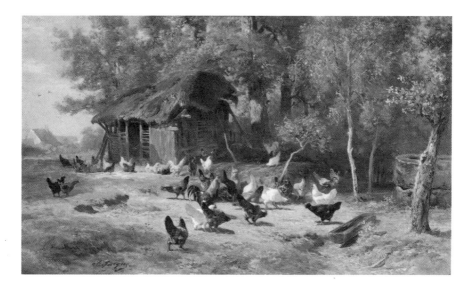

Men of Destiny

After Jack B. Yeats

July, with its pressing light, its high note of optimism, was ending. Storms came easier day by day and one roiled up now from the horizon with great cauliflower clouds and a bouncing wind. Patrick skelped from one side of the pier to the other until the boat docked, then he fell in beside Malachy who tore up the pier like a man on fire.

'No catch?' Patrick said.

'There were mackerel out by Mullaghmore, but I left them be.'

'Why so?' said Patrick, juicing for the truth from Malachy's own lips.

Malachy stopped and stared at his nephew. 'Stop following me. Go home where it's safe.'

'I won't,' said Patrick. 'You'll be glad of me by and by.'

Malachy ran towards the hill, dodging over walls, hoping to lose Patrick. He's a conundrum, Malachy thought, a fool of a lad. He slipped behind Aggie's cottage and watched Patrick sail past on his bicycle. Malachy waited below the house until the sun was swallowed up by the sea, then he slunk through Aggie's gate, back down to the pier.

He rapped on the hull, three knocks followed by three more; he heard the answering whistle and leapt onto the deck. The hatch opened and Malachy slid through; the stench of sweat hung in a rich fug, drowning out the fish-gut smell that he was used to. The men were sitting on the boxes, rocking with the movement of the boat.

'We'll wait for the storm to hit and then we'll move,' Malachy said. The men nodded.

Jack B. Yeats, 1871–1957
Men of Destiny, 1946
Oil on canvas, 51 × 69 cm

Walsh turned to Malachy. 'Did you hear what Pearse said? "The only thing more ridiculous than an Ulsterman with a rifle is a Nationalist without one."'

Malachy looked hard at Walsh then he laughed; the others laughed too. Outside the wind gusted and moaned, lifting waves under the boat that made it judder from stern to bow. But still it didn't rain.

'Jesus, what's keeping it?' Malachy said. 'A Sligoman praying for rain, hah?'

The men laughed again then sat in silence and smoked, lighting one cigarette off the butt of the last. The boat swooned high and higher, then jolted downwards, making the other men look like heaving puppets to Malachy. Eventually the rain began to pelt and, when it was thundering onto both port and starboard, Malachy gave the signal. The men squashed their cigarettes and Walsh opened the hatch and climbed out. They passed the boxes hand over hand to the deck, then each of them crawled up, keeping their heads low.

Walsh stood on the pier and whistled; Aggie stepped into view and nodded. The rain thrashed and the wind sang. They carried the boxes up to Aggie's cottage, jemmying them open with a crowbar on her tidy mud floor. Aggie threw the splintered wood from the boxes into her fire and watched it blaze. The men loaded the guns into the coffin Aggie had made and she sealed it shut, the same way she did after every village wake.

She stood by Malachy and whispered the names of the townlands to him: 'Ballinagallagh, Cashelgarran, Gortarowey, Lisnalurg, Cregg, Kilsellagh.'

He repeated them back to her. 'Ballinagallagh, Cashelgarran, Gortarowey, Lisnalurg, Cregg, Kilsellagh.'

'Always have a name ready on your tongue, Malachy. Say it surely. God speed, son.' Aggie made the sign of the cross on his chest and pushed him out the door.

The men lifted the coffin onto the cart. Walsh, the slightest, was dressed in Aggie's old shawl and skirt. The men flanked him and they each put a hand to the cart and pushed, heads bent against the storm.

By Barnaderg Malachy's feet were bleeding. By Mullaghnaneane he was cursing himself for thinking this could be done at all. He heard a low whistle and raised his hand. The men stopped the cart. A figure stood out on the road ahead; the man came forward, his uniform soaked to a dull grey.

'Whose funeral is this?' the soldier said.

'James Walsh's.'

'Of what townland?'

'Gortarowey.'

'And who are you?'

'His brothers,' Malachy said, 'and his wife.' He indicated Walsh who kept his chin tucked to his chest. 'We're making for Drumcliff.'

A whirr behind the cart made the soldier lift his rifle across his chest. The whistle they had just heard sounded again. Malachy turned to see Patrick hove into view on his bicycle, the wheels sluicing through the ruts on the road.

'Malachy,' Patrick called, 'Malachy! There are soldiers doing searches on the road near Tully. I came to warn you.'

The soldier raised his rifle and shouted, 'Stop!' Patrick, his eyes blinded by the rain, kept coming. 'You there,' the soldier shouted. 'I said stop. Stop!'

Patrick barrelled forward and the soldier aimed. Two shots cracked the air and the soldier fell. Patrick hopped from his bicycle and stared at the man on the ground.

'You shot him,' he said, turning to Walsh, 'you shot him dead.'

The men dragged the coffin off the cart, heaved it across a wall and made for the bog. Malachy and Walsh went to follow, hauling the soldier's body between them.

'Go ahead of us,' Malachy said to his nephew. 'And don't look back.'

In the roadway, the wheels of Patrick's bike spun. The empty cart rattled and grumbled under the rage of the sea-storm that did not want to let go of the land.

EILÉAN NÍ CHUILLEANÁIN

A Musicians' Gallery

It echoes with tapping, chatter, jabber,
Noise converging on a teased out sound;
Harmony remembers and at last
Squeezes into a dominant, as the angel
Tests the note he has found
In the depths of the lute, wringing
Resonance from a tight string.

His body freezes alert, as a voice
Echoes around the stars. The saint
Beside him seems at once listening and singing.
He listens, and two rooms away
A man listens to his son
Who is tensed around air, breathing
A stave that flutters and blows away –

To land at a wedding, where pipers clutch
Bagpipes awkward as bulging animals
Kicking to escape the clamped elbows.
The dancers hammer the floor: no rest this night:
The wedded pair sit steady. At another wedding,
The fluteplayer on a cramped balcony dangles a leg
Over the rail, still playing. Who is listening,

Who can catch the lost bar? The f-shaped hole
On the cubist violin swallows it up until
The fiddler's return to haul it out, bend
Her shoulders in a crouch, alert for the signal
To release the note again, matching
The wedding racket and the heavenly echo
Calling to the angel to let his own note sound.

It is not natural for an angel,
But he must do it, the long note pushing him
Into a body. Now the feet first learn
The push, the calf muscle stretching, the heel
Groping for purchase to fit the vibrating ground.
This is where he finds presence, the tug and pressure,
Flesh holding the music in place, company.

Marco Palmezzano, *c.* 1460–1539
The Virgin and Child Enthroned, with
St John the Baptist and St Lucy, 1513
Tempera and oil on panel, 218 × 188 cm

EILÍS NÍ DHUIBHNE

Castles in the Air

A Dream Catalogue

In my garden I stand like a blade of grass. I cook a stew of shadows in a beechwood casserole. Cabbage light as butterflies, nettle breezes. Silver water from a spring my beverage. My fingers are the bristles of a brush that canter through a canvas meadow.

For years I have recorded my dreams
Insofar as the flimsy net, my only tool, can catch
swallows as they fly into the clouds
Or fishes darting under the slimy rock
Called I forget.

These are my themes:
Rivers breaking banks, tsunamis overwhelming,
Missing buses, friends vanishing around corners
Like eager rabbits finding fast their burrows.
Of course a certain share of sexual stuff
Involving ancient friends and complete strangers.

Then, houses.
Like mushrooms in autumn fields
They crop up every night
My dreams enjoy a permanent building boom.
In my unconscious there are ten thousand mansions

Also, cottages and bungalows
Villas, palaces,
And castle upon castle.

Selection from the Catalogue
(i) Dreams of Houses
(a) Norman Tower House

I am going to a meeting in a large old Norman castle or tower house. Thick stone walls, grey as cobweb. Getting in involves climbing over a table. I am with a woman who has difficulty and at one stage is upside down on the table but I manage to climb up without trouble and get my friend standing the right way up. We both enter the castle.

Stone walls, old oak furniture. A fire burns on a hearth right in the centre of the room, although there's a fireplace on the wall. There is indeed an opening above the fire for the smoke to escape, and the room is warm and cosy.

Several young people are sitting around, doing nothing.

In a corner is an oak cradle and in this cradle is a baby, wrapped in a red damask robe. I lift the baby – a boy, aged about two, he is rather thin and adult for a baby. I cuddle him and give him something to play with. It's a thing I happen to have, made of white fibreboard stuff. He plays with it and after a while I notice that he has crumbled it away and most of it has disappeared. I hope he hasn't eaten it.

I wonder why nobody is doing any work. I realize I have been in the castle for a very long time and remember that I probably have other duties outside. It occurs to me that everyone is waiting for me to leave – this was to be a short social call and I have been there for hours.

I put the baby back in the cradle and say goodbye.

(b) Traditional Irish Farmhouse

I am with my sister, visiting a farmhouse. The farm is a traditional one: a house and several outbuildings surrounding a yard. The house is thatched and sheltered by big cushiony trees. The outbuildings

have been converted to studios: large light rooms. They are painted pale turquoise, and have wooden beams on the ceilings. However, these studios are falling down. I say or think that Mary Robinson started this – rebuilt the farmyard outhouses as places for guests. But now they are all collapsing.

(c) Artist's Home with Crocodiles

I am driving a group of artists. We stop at my friend Gerard's house. His wife, who is an athletic-looking woman from New Zealand – tall, no make up, very self-confident – asks me if I have brought the butter and something else which I forget. Her husband had given me these things. I say no. She asks again and I say no again, I haven't got the butter. I speak more firmly and am annoyed that she expected me to bring something.

She shows us their bedroom, which is new or newly renovated. It is a large, nice room. The floors are made of bamboo and the wardrobes are like my own wardrobes at home but the room is dim and restful, like a room in a hotel.

We go into another room in the house, which keeps growing bigger (as houses do, in dreams). This is a living room of some kind. Just as we are entering it, I see a tiny green crocodile peeping around the leg of a chair. She says, oh yes, we have a pet crocodile, it doesn't bite. But soon more and more green reptiles appear until the floor is covered with them. Some are slimy, like jellyfish or pools of water, others have a distinct shape. I am barefoot and can't avoid stepping onto them. I ask if it is dangerous and she says, no, but if you get stung don't put your hand to your face.

I try to escape from the room but can't.

(d) Palace

I'm in a very big high building, a palace. All pillars and marble and lofty ceilings. First I am on one of the upper storeys, maybe the top. Then I start to come downstairs. There is a big pool, a sort of beautiful marble indoor lake or swimming pool. The water is warm and delicious and I swim around, along by the edge of the pool – it's surrounded by a low marble wall.

I get out of the pool and continue on my way, downstairs. Then there is a slight fuss and a row of soldiers or officials march up the winding ramp at the side of the building. 'The King is coming!' There are many minions preceding the King, but finally he does come, riding on a horse. He just rides on, past me, up the ramp. Nothing much happens but I feel pleased that I have seen the King, even though I didn't expect to. I didn't even know there was a king.

Appendix

The palette of my dreamscape: olive green and grey and black and silver.

Gerard Dillon, 1916–1971
Nano's Dream Castle, 1940s
Oil on canvas, 77.8 × 102 cm

JULIE O'CALLAGHAN

After Gulliver

Little Green Fields by Gerard Dillon

Cast forlornly upon the whaleish waters,
flailing about,
by some miracle, land appeared.
Thereafter I swam with hope
extending my legs downward
searching for the sandy floor
I knew must lie below.

My foot landed softly:
I would live more.

Crawling monster-wise
onto a small beach,
burrowing to sleep
under the blanket of sand crystals
my new home provided
until sun tapped my cheek.
Whereupon I gazed crustily
in all directions
discovering what place this was
I had pioneered.
First vision:
Little Green Fields.

Second vision:
how little green fields
are sometimes blue and pink
and over in that direction are orange.
Each a kingdom,
each a stone-barricaded world.
The Realm of the Chicken,
District of Tillage, White Cottage Province,
Horse-Scratching Region,
The Universe for Leaning and Smoking
Beside a Buried Saint
Lying in the Soil Beneath your Feet
and the Zone for Ancient Structures
here and there telling old stories
to which no one is listening.

Third sight:
there is only one gateway
through these little green fields.
I have searched everywhere
and found this tiny wooden
barrier on hinges.
It leads to the mysterious
green field
of granite monuments.

I carved my name.

Gerard Dillon, 1916–1971
The Little Green Fields, c. 1946–50
Oil on canvas, 40.5 × 89 cm

DENNIS O'DRISCOLL

Memo to a Painter

Why put so opulent a gloss on the picture
when the unvarnished truth stares you in the face?

Is it not all a bit rich? Why not shame the devil,
tell the story straight, stick to the honest-to-god facts?

Don't fall into the trap of doting parents,
who idolise their babies as some golden calf.

Desist from gilding the lily, over-egging the tempera,
laying a false god before your gallery worshippers.

Every figure witnessed through the stable's
wormy frame was truly humble,

except of course for those slumming visitors
you admit: star-struck kings with gift-wrapped

frankincense and myrrh – odours of sanctity
to offset the noxious fumes of ox and ass –

who kept their distance
from the unkempt shepherds,

the great unwashed whose offering
would morph into a sacrificial lamb,

its horns snagged on the barbed wire
of a crown of thorns.

The Adoration of the Magi ('style of Pieter Coecke van Aelst', 1502–50), National
Gallery of Ireland, depicts the Nativity in elegant surroundings, without the stable
or its animals.

Style of Pieter Coecke van Aelst, 1502 – 1550
The Adoration of the Magi, mid-16th century
Oil on oak panel, 65 × 48 cm

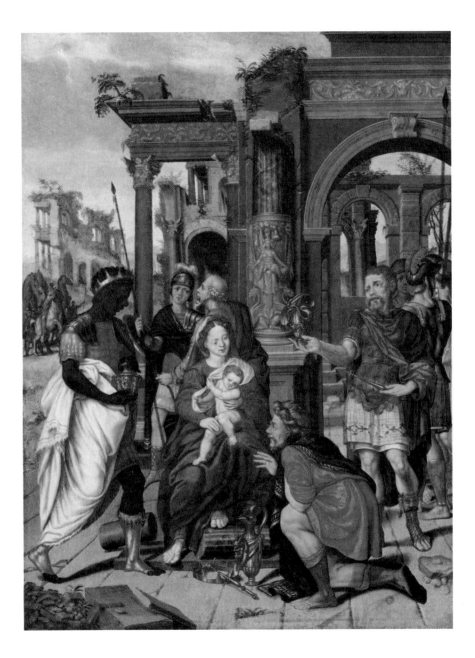

MICHEAL O'SIADHAIL

The Lamentation over the Dead Christ

(On the painting by Nicolas Poussin)

Embalmed, the bird of life has flown
His ribcage, head cradled by his friend
And feet-first welcomed to his tomb
By Joseph; Magdalene has kissed
His hand and holding up his wrist
Inhales the aloes that perfume
Her grasp as grieving shoulders bend
Near Mary Mother, Mary unknown.

And Arimathea's Joseph dared
Ask Pilate's leave to lay to rest
Christ's body in the tomb he'd made
To house himself; now unafraid
He's greeting his dead garden guest –
Rich follower whose room is shared.

It's John who's holding up Christ's head,
The loved disciple who had leant
On Christ who fell to washing feet
For those rough men he means to treat
As friends, like his acknowledgement
That John's his mother's son instead.

Blue-mantled Mary tilted stands
To wake this god-man she begat;
Her hidden left-hand wipes an eye
While showing in tree-shoots nearby
Her now fulfilled *magnificat.*
Behold God's handmaid's spread right-hand.

The loving Mary Magdalene
Still keens. Returning to the tomb
This hallowed guide for all who've whored
Will be the first to find the lord
She may not touch, the master whom
She'll claim as gone to come again.

The other woman, still unknown,
*Ochón*ing by the wailing wall
Is Mary called by many names
'Of Clopas', 'mother of Great James'
Anonymous witness for us all
Who'll love by memory alone.

In offset glory of defeat
Defined against the gathered night,
Lamenting do they dare to ask
Can Christ rebound from this abyss?
Their questioned hope now hangs on this.
Bound by their undertaking task
Five faces catch reflected light
Still shining in Christ's winding sheet.

Nicolas Poussin, 1594–1665
The Lamentation over the Dead Christ, 1657
Oil on canvas, 94 × 130 cm

LEANNE O'SULLIVAN

The Kitchen Maid

All the ceremonies of the kitchen
come through – sunlight on the bread boards
and flour swept up from the bare floors;
so her footsteps vanish like pools of rain
on the road, her swiftness towards the fire
unproven where she heaps the deeper red
around the bastible, enough for
mystery to keep and the soft notes of bread
to rise, companionable, from their dark centre.
The meal table set and laid, the vessels
shining with room for the guest portion,
a sign that means kind labour
without speaking or remembering itself,
but heard about afterwards, in her absence –
how a certain light breaking across the table
might set a whole world in motion.

Diego Velázquez, 1599–1660
Kitchen Maid with the Supper at Emmaus, c. 1617–18
Oil on canvas, 55 × 118 cm

JUSTIN QUINN

Argenteuil

Where I grew up the concrete and the brick
boxed off small bits of grass and never changed.
It seemed that everything had been arranged
a hundred years ago and left to tick:
the whole class shouting anthems and rote answers,
priests walking through the grounds in black and grey,
a rugby-club disco on Saturday –
a set course of exams, careers and cancers.

I'd take a bus to town. The rooms were silent
and full of other strangers. Though still a boy
I'd look at this a half an hour, my gaze
– like that of earlier thousands on this island,
and France before, starting in Argenteuil –
with all those yellows, golds and reds ablaze.

Claude Monet, 1840–1926
Argenteuil Basin with a Single Sailboat, 1874
Oil on canvas, 55 × 65 cm

BILLY ROCHE

Child's Play

S he had the game all set up now: her dolls and toys and little bits and pieces spread out all over the bed, all waiting for the story to begin. There was her posh doll, the one with the hat and gloves, and there was her Raggy Maggie, and her big porcelain doll with the frilly dress. The one-eyed one lay on the floor by the door; she wouldn't be using that one today. No, there was no room in her story for a one-eyed lady. The one-legged Pinocchio though would get a part – as an actor in a play maybe or someone back from the war or something on those lines. Her little brother's toy cars and lorries would get an outing too: they were all lined up on the window sill so that, from the bed anyway, it looked like a far off, busy road. Behind the piled up pillows lay the mountain lake, clear as glass and deeper than the ocean. Her story would begin there. Yes, she knew the beginning (she always did) and how it would end. The middle was a total mystery though and that was the part she loved the best: the surprises, the little twists and turns.

She was just about to begin when she heard the front door bell ring and she audibly gasped and held her breath. Her mother answered the door and she could hear voices rising from below. She had told her mother what to say – that she was sick or had a head-ache or a bit of a temperature – when the girls called for her. She didn't want to go out and play today, she wanted to be on her own.

She went to the bedroom door and listened but she could not make out what they were saying. If it was only Rosie Ryan she'd be alright. Rosie would just listen and go away. But Janet O'Grady would not just listen. Janet would ask a load of questions and inter-rogate you until you buckled. She'd need to know everything. *'What kind of a headache?'* and *'When did this come on?'* and, *'She never said,'*

Walter Frederick Osborne, 1859–1903
The Dolls' School, 1900
Watercolour and pastel on paper, 45.2 × 59.5 cm

so that the person doing the talking felt like they were concealing something even if they were not. Her mother wouldn't stand for any of that old nonsense of course. No, she'd send Janet off with '*a flea in her ear*'. She hoped her mother wouldn't be too sharp with Janet because the last time Janet gave her the third degree her mother had snapped and told Janet to, '*go off out of that and don't be addling me,*' and Janet had harped on about it for weeks afterwards, calling her mother names and making fun of the shape of her face every chance she got.

She heard the front door slam and went to the window. But she did not draw back the lace curtains because she knew that Janet O'Grady would be walking away and looking back up to try and catch her looking out. She could picture Janet's freckled face and her veiled, squinting eyes and she was sorry she hadn't just gone with them for peace sake. She had a good mind to grab a few things – her one-eyed doll or the one-legged Pinocchio – and run after them down to the corner where they were going to set up their buy-and-sell stall.

Janet O'Grady would be giving out about her now. She'd be dis-secting and analysing the excuse. She'd go over and over it again and again until she figured it out and then when they came face to face tomorrow or the next day Janet would confront her with the facts: namely that she didn't have a headache or a temperature in the first place, that she was not ill at all. No, she just wanted to be on her own, playing with her dolls. Her dolls! At her age! And as for her friends? Her friends were not needed, they were not wanted. Janet O'Grady would look to Rosie Ryan then for confirmation but Rosie would not say a word, she'd just stand there and look down at her shoes, mortified.

Her mother came up the stairs and into the room. She had her raincoat on and she was fixing her hat because she said she was going down as far as the shop and it was going to rain; and when her mother was gone she knelt on the side of her bed and began to play. But some of the good was gone out of it now and she wasn't

sure if she wanted to go on with it or not. She had to force herself to continue. 'Shall we? Yes, we shall. Bring the car round James and let's head for the lake.'

Janet O'Grady was still on her mind, eating into the story. She wondered if there were other Janet O'Gradys out there, if they were everywhere, and if they were everywhere then she would have to learn to ride roughshod over them or else they'd ruin everything. And she began to realize then that that was probably their sole aim in life: to pick and to probe and to badger and whinge and moan until joy turned to sorrow and hope to regret and all of the good in the world was gone.

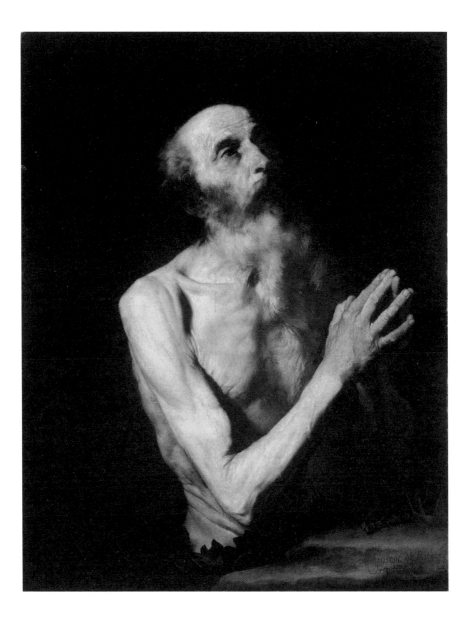

Jusepe de Ribera, *c.* 1591–1652
St Onuphrius, 1625–29
Oil on canvas, 90 × 70 cm

GABRIEL ROSENSTOCK

Onuphrius

Mé Onuphrius
mé guth
mé tost an ghaineamhlaigh
gan d'éadach umam
ach clúmh

Spéirbhean tráth a bhí ionam
gur bhronn Dia féasóg orm
trína séideann leoithne na bhFlaitheas

Mé Onuphrius
briathra milse Dé a chothaíonn mé
is a mhúchann mo thart

I am Onuphrius
the voice
the silence of the desert
my only garments
the hair on my body

I was once a woman of rare beauty
then God gave me a beard
in which the breeze of Heaven plays

I am Onuphrius
the sweet words of God sustain me
and quench my thirst

DONAL RYAN

Grace

There were two boys sitting near the back of the bus this morning. The only empty seat was in front of them. As I approached, the one on the outside held my eyes. His leg was stretched across the aisle. His tracksuit had a stripe along its length made from tiny shadow-women, sitting back-to-back. I smiled at the sight of them. The boy looked at his friend and said something in a high voice. They spat sudden laughter. I knew as I sat that they would try to cause me some torment. And I wondered how pleasure could be found in the causing of sadness in others, how young men in a land of fertile soil could choose to spend their precious time on such a wretched pursuit.

When I reached the gallery Zody was waiting. She is a citizen of Ireland now. We stood looking at this painting for a long time. It is you, Grace, and your family, Zody said. She did not mean to be unkind but her words wounded me. Rain falls behind the people in the painting, as though driving them from their home. The man stands straight, his chin is high.

The victory my father achieved in the village was of a particular type. I cannot remember the correct name for it. A priest told it to me who visited our school in the township where we learned to speak English after I had explained to the class how our family had come to leave the village of my birth. The word meant that more was lost in battle than was gained in victory. My father refused to pay a tribute to the elders from our harvest. Let them raise their own, he shouted, and our neighbours clicked their tongues and sighed but did not argue aloud. No one came to help with the saving of our crop. The rains came while we laboured and washed our wealth

Erskine Nicol, 1825–1904
An Ejected Family, 1853
Oil on canvas, 50 × 82 cm

away. My father bellowed at the gushing sky as my mother stood silent behind him. The elders decreed that we were to be shunned. So tall my father seemed as we began our journey to Kinshasa, so noble and unswerving as he led us through the centre of the village. The elders' eyes followed him; they mourned their drowned tribute.

My father hardened and crossed me from the page in his heart that bore his children's names. He left me in the house of my mother's cousin. Days and nights coiled themselves together. My father did not return to pay my mother's cousin for my keep. But my visitors paid handsomely. I found courage one day and ran from that house. I took a lift in a pickup truck. Glory, it said along the door. A dove flew alongside the word. I jumped from the truck at the edge of a town that had hanging above it a dark cloud. I worked in a factory that stank of sweat and molten plastic. I slept at night in a narrow bed in a long dormitory of other girls and women. I dreamt often of my family and the village and knew I would see neither again. I dreamt of our crop, being rinsed from this earth by the bleeding sky. Then I ran again, across the world.

I have sought refuge here. I work for a man who parked one evening near the entrance to the asylum centre. As people walked by him he said English? You speak English? And some of us agreed to go with him to clean offices and supermarkets. He said, slowly: You'll never be asked, but if you are, say you're French. Act offended. If you're asked for proof, say: Do *you* carry proof of *your* citizenship? That'll bamboozle 'em! Then say nothing else. Alright?

One evening he brought me to the door of a house on a narrow street. What do you think of this, Grace? Leave your bucket of tricks there, Grace, you need do no cleaning here tonight. I only want to show you it. Show me what? The house, of course, he said, and laughed, and looked at me. His eyes reminded me of the dogs in the township. Would you like to live here some day? He gestured about him, smiling. He was trying to make me believe him foolish, harmless. There was a garden behind the house. The sun pooled on the grass; small white flowers danced in it. I imagined myself sitting

there, unseen, at peace. I thought of Satan, drawing Christ's eyes to the glistening world beneath them, promising. I would live there, and he would have a key. There'd be no peace.

I see my employer now, standing on the street. He is talking to a well-dressed lady who holds his hand in both of hers. God rest her, the lady is saying. If there's anything we can do... My employer's wife was ill for a long time. He had often stood and spoken of her, watching while I worked. He would have a new mop-head for me or a bottle of bleach, as a pretence. It's terrible hard, so it is, seeing her that way. My heart is weary, Grace, he would say. Go easy, Grace, take your break. Come and sit with me a while. And he'd talk again about the little house and say It's yours for only a tiny rent, we could work something out, as soon as you're regularized. Won't it be lovely, Grace?

And he believes in his soul, I think, that it would be lovely. That he would visit at his will and I would smile and prepare his food and surrender to him. Just as those boys on the bus this morning thought that I would surrender my joy to their dirty trainers kicking against the back of my seat and their hissed words of spite, their phones descending from above me, flashing and clicking.

He's smiling at the lady; he leaves his hand in hers. His eyes have a light in them, a glint, not of tears but of triumph. This is his victory, he thinks, his time to reap. He's not thinking of the rain.

PATRICIA SCANLAN

The Anniversary

She is flustered as she hurries down the ramp at Killester Dart station shoving her purse back into her bag, fumbling at the clasp. *You don't have to go if you don't want to,* Hannah tells herself. Her heart races. She dithered all morning before slipping into her good Sunday coat and wrapping a lilac pashmina snugly around her neck. Although there is heat in the sun, autumn's chill is in the air. Frolicking russet leaves drift down from overhanging branches. The next train is due in four minutes, time enough to calm herself and make the decision to return home or carry on in to town. Her mobile rings as she reaches the shelter. She scrabbles in her bag, her gloves making her clumsy. Her heart lifts as her daughter's name appears on the screen.

'Hello, Rachel.'

'Hello, Mam, I rang home and there was no answer, are you out and about?' Hannah smiles. Her daughters ring regularly, checking up on her.

'The minders have become the minded, they see us as children now,' Frank, her beloved husband, had said ruefully when he and Hannah had made a spur of the moment decision to drive to Avoca for lunch to celebrate their wedding anniversary a few years ago. They had forgotten their phones and arrived home that evening to find a host of messages from their offspring.

She'd had to make three phone calls of reassurance.

'You should have told us where you were going.'

'We were worried, we thought something bad might have happened.'

'We thought you were in A&E!'

'Sorry,' Hannah had apologized meekly three times, feeling like a naughty child. 'It was spur of the moment, we were being spontaneous,' she explained, smiling at Frank who winked at her, age not dimming the twinkle in his bright blue eyes.

'You're both in your eighties, Mammy, we're entitled to worry about you,' Maria, their youngest, had said crossly. 'The next time you go on a *spontaneous* jaunt bring your phones with you, won't you?'

'Yes, dear.' Hannah tried to hide her irritation. You'd think she and Frank were *youngsters* the way the girls were going on.

'So where are you off to?' Rachel asks.

'Just popping into town, love, I've a few things to get. Here's the train. I'll ring when I get home,' she says as the green carriages rumble past and draw to a halt with a squeal of brakes.

Hannah steps through the doors and sees an empty seat beside a window. At this hour of the day she usually has her choice of seats and she settles herself for the short journey.

The sun is glistening on Dublin Bay, sprinkling silver sparkles on the gently undulating water. The tide is in. Clontarf looks picture-postcard pretty. Her thoughts drift back to another time, another postcard-pretty setting as the train comes to a halt at the depot.

Avoca, where she and Frank had honeymooned many years ago, was so beautiful. Their wedding had been a small affair. Very different from the glitter and glister of weddings these days. It's ridiculous the expense couples put themselves to, Hannah sighs. She and Frank had been married at seven-thirty in the morning, surrounded by family and a dozen friends. The wedding breakfast had been held in her sisters' front parlour and they had all tucked into a fry before cutting the cake and raising their glasses filled with sparkling Babycham. The guests had gone to work and she and Frank had taken the Wexford train to Avoca where they had spent the first few days of their honeymoon in a guesthouse near the Meeting of

George Barret, 1728/32 –1784
A View near Avoca, c. 1760
Oil on canvas, 59.1 × 73 cm

The Waters. They hadn't had a car then, they'd had very little, but they were happy.

The train starts up again and they rattle into Connolly, then Tara Street before it's her stop. She emerges onto Westland Row and crosses at Lincoln Place, tempted to have a reviving pot of tea in the Davenport and get the train back home.

Hannah's grip on her handbag tightens as she reaches the National Gallery. Her and Frank's favourite place. A scene of many happy dates. She hesitates then climbs the steps. She inhales the scent of wax polish as she walks through the familiar surroundings. The sound of her heels on the gleaming parquet floor breaks the silence. She lingers in the Miltown Wing. The Green Rooms, she calls them. The serene energy soothes her and Hannah relaxes a little before making her way to her and Frank's special painting, George Barret's *A View near Avoca*, relieved that no one else is there to intrude on her precious moment.

Hannah studies the much-loved painting, admiring the brushstrokes that created the surging river, captured so expertly by the artist. The gold-green trees fringing the riverbank remind her of how she and Frank had laughed as they tossed armfuls of crisp autumn leaves at each other during one of their walks. 'Oh Frank!' she whispers as a stabbing heartache grips her in a vice. Tears brim.

She hears footsteps. '*Go away*,' she pleads silently hating that strangers would trespass on her memories. She makes a valiant effort to compose herself as the footsteps draw closer.

'Mam!'

Hannah turns, astonished. 'What are you all doing here?' she asks catching sight of her three daughters.

'Did you think we'd let you come on your wedding anniversary visit on your own?' Rachel tucks her arm in her mother's. 'I knew where you were heading when you said you were going into town, so I rang the girls. We can have lunch in the restaurant here before they go back to work.'

'Oh girls, you're so good to me. Your father would be proud of you.' Her voice breaks.

'And Dad would be so proud of you, coming here on your own on your first anniversary without him.' Maria squeezes her hand and Lisa gives her a kiss. Hannah feels an easing of her grief as her daughters' love and kindness enfold her. They turn to look at the painting and Hannah feels as though her late husband is there with them.

PETER SIRR

Brueghel: *The Wedding in the Barn*

The leering, brutal figures
squat in their island habitat,
. the gypsies caught on camera
throw a punch, adjust a dress
and at the wedding in the barn
the peasants grope and tumble,
twist and flail. Have you seen
this one? The thin-faced relatives
squabble over a purse of coins,
the sharp-nosed others take it all in,
the pipers check each other out,
it's a race, the notes on fire. What
would you do if the kettle
boiled over? This one's had it,
his head slumped on the table,
hell is a furious music. What
would I do only fill it again.
The short one in the reality house
is evil, Cheyenne is
the bubbly one, her tiara's
askew. You to be drunk and me
to be sober, Kitty lie over
close to the wall. The fat
peasant lunges at the cameraman.
Brueghel sighs: the ratings are up
but the complaints are pending.
Fake tan, oiled muscles, that old
hunger for the authentic, the white

headdresses, the faces
outliving effort, shot
after shot to be trawled through,
assembled, it is not them
but us, nor their music
lifts the roof off, sets the walls on fire.

Pieter Brueghel the Younger, 1564–1638
Peasant Wedding, 1620
Oil on panel, 81.5 × 105.2 cm

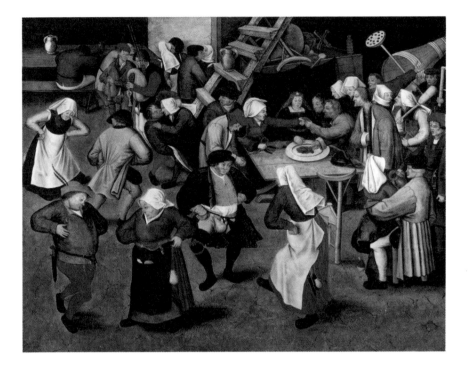

John Butler Yeats, 1839–1922
Rosa Butt, 1900
Oil on canvas, 92 × 71 cm

COLM TÓIBÍN

John B. Yeats

John Butler Yeats was a great talker; his letters are among the best ever written by an Irishman. His mind was original and playful; he was fascinated by life, so fascinated indeed that the dull idea of making a living, or bothering about fame or success, did not interest him very much. He was close, in his way, to Henry James Senior who oversaw the lives of his sons – the philosopher William James and the novelist Henry James – with a mixture of zeal and tolerance, becoming, much as John Butler Yeats did, more of a child himself in the process. Neither of these prodigal fathers was good at finishing things. Starting things was too interesting; or changing their minds half way through a project. They were good at friendship and were much sought after by people of intelligence. Both men produced two sons who were industrious, deeply concerned with finishing every project they began.

Since John Butler Yeats had formed the habit of working and then erasing and then starting again, his friends and supporters – including Lady Gregory and the New York lawyer John Quinn – encouraged him to make quick drawings in pencil of people he liked and admired. Over many years in Dublin and London and then in New York (where he moved at the end of 1907 and where he died in 1922 at the age eighty-three) Yeats did brilliant sketches. It was clear that he was entranced by the human face in all its complexity.

In the paintings and drawings of his two sons, he captured something also of their inwardness, of what they kept hidden to use when they worked. There was always a sense that the father, on the other hand, kept nothing hidden, and this may explain his waywardness as well as the range of his mind. He looked outwards; he enjoyed what he saw. He was not given to introspection.

In his letters there is great wit ('I think lots of men die of their wives and *thousands* of women die of their husbands' or 'I wrote to Willie some time ago and said it was as bad to be a poet's father as the intimate friend of George Moore') and large-hearted tenderness ('Without imagination – and of the kind that creates – there is no love, whether it be love of a girl or love of a country or love of one's friend or even of children, and of our wives').

In other letters he observed that it was easier to write a book than make a painting. When it mattered to him, however – with his sons, for example, and with some close friends – all of his humility and generosity of spirit and love of the world could emerge in an oil painting. One of his finest is his portrait of Rosa Butt, who was his contemporary, a woman he had known for many years.

There is also a lovely drawing of her done around the same time, when he captured her spirit with strange force and dignity and an inner light. As a student, Yeats had become friends with her father, the lawyer and nationalist politician Isaac Butt. Yeats liked Isaac Butt enormously, having learned, as he said, 'to judge people by their manner' which he believed 'a surer indication to character than deeds, though it may be heresy to say so'. Years after Isaac Butt's death, John Butler Yeats wrote: 'Such is the charm of person-ality that the man who has it is forgiven, though his sins be scarlet – for instance loveable Isaac Butt.'

His oil portrait of Rosa Butt was made in 1900, when they were both sixty or sixty-one. She has a great distant dignity in the picture. Yeats captured what he most admired – a sense of the human presence in the world as mysterious, intriguing, worthy of close study, but something also which could not be easily defined or measured. Thus Rosa Butt's face in repose has a fluidity as well as a stillness, a sadness but also a rich inner life, an aura which has much withheld but also exudes a sense of worldliness. She is someone who would be at ease in company and also content when alone. She has a freedom which one could associate with what Yeats's son would call

'custom and ceremony', a freedom which has given her face and her pose here a formidable and ambiguous power.

Since the painting was done in the year Yeats's wife died, it is easy to imagine the painter as an unsettled widower, whose life was funded by his elder son and controlled by his two unmarried daughters, and whose marriage had been less than happy, studying a woman whom he admired. All of his life he thought about what he might have become. He knew how much damage his impecunious ways had done to his wife and his daughters, but he knew also that, had he become a successful barrister, he would have ruined himself.

Now, after his wife's death, he had freedom and he could make a choice; he chose further freedom. He chose to be bohemian and poor, to let his mind take him where it would, to seek out good company, to study life closely, to put more energy into his talk and his letters than into his art. His family made desperate efforts to lure him back to Dublin once he settled in New York, but he would not return.

It is nice to think that Rosa Butt represented for him something that might have been; she appears in this portrait as a sensibility he admired, but which would contain him. He did not wish to be contained. But there must have been times in the boarding house where he lodged in New York when the poise in her face, the sense of ease and wit and civility which he gave her in this portrait, came to him as a dream of a life he regretted not having, or at least recognized as oddly beyond him.

WILLIAM WALL

I Stepped into Allegory

I stepped into allegory and found myself leaving the burned-out house, the crows pitching in the rafters, their raucous laughter, a grey day slanting in the sockets of the windows, and there before me was the whole panorama of desolation, and they were digging a grave for the patriot dead as indicated by the presence of two soldiers with shovels, a cluster of grieving relatives (to include woman, child, artist) and the gentleman beneficiaries Church and Capital. The soldiers worked with their backs to each other but in the same grave. A soldier is a natural digger of graves having to hand his trusty trenching tool at all times. The two gentlemen were agreed that things were looking up, the country was on the mend now that the patriotism had stopped, it would be business as usual and not before time. We stood together looking down on the beaten artist, the bereaved family, the soldiers and the dead patriot. Who owns that ruined house, I said, pointing back at the place I came from. Everyone turned to look at me.

Sean Keating, 1889–1977
An Allegory, 1924
Oil on canvas, 102 × 130 cm

MACDARA WOODS

Members of the Sheridan Family

On detours through the Gallery
From Merrion Square to Nassau Streeet
For years I've been disturbed by this
Unfinished scene of absences:
Three present figures in a sickly shell
As if strayed in from other frames
And grafted here: not family
But members of Aloof school of and

You a dying man perhaps already dead
Before the artist started the commission –
You your brother's wife their son...*I hope*
It may engage a pleasing melancholy
Was Landseer's stated wish –
Blood-distance and disease between
You all and toiling back
To pick up in the Diplomatic Corps

But you don't really look
As if you have the strength for travelling
To keep that certified appointment
In Samara: To be dead this month at thirty
In the British Embassy in Paris –
The strength to face the rush and bustle of the railway
The weather
And the Channel Packet steamer –
Which may explain discrepancy of dates

You look hardly strong enough in fact
For make believe
To have stepped outside into the garden say
A moment past in
Heavy dressing gown pantouffles and summer hat
And then stepped in again to rest –
Stage properties of nearing death:

The stinking rasp of life is missing
From the lungs –
The minute living forms that drive
The hot-house show along
Are not at work behind the scarlet lips
And lassitude but the gothic
Sunk-eyed stare is true and fixed on the immensity
Of seeing the rolling spool of light
Run out into the dark of May
And feeling almost there at last
Burial Place Unknown:

The woman and her son
Share in the well-presented emptiness – she
Watches from the far side of the galaxy
Gazette set down upon her knee
Between you and the boy
Who seems to stare as fiercely as yourself
At what it is you see outside the frame
Where we the audience
Are taking part from front-of-house

In this Smock Alley scene rehearsed:
The painter's landscaped flats
Our dialogue with silence
Not family but members of –
And not a one of us who feels
The rigor and the fever and the intermittent cold
Whatever time we wait
Whether we know our lines or not
And even if we never speak
Or breathe at all
Is ever more than half a breath from it

Edwin Henry Landseer, 1802–1873
Members of the Sheridan Family, 1847
Oil on canvas, 107 × 166 cm

VINCENT WOODS

The Piper in the Snow

The piper played a reel:
Na Prátaí Geala Bána
The young girl danced
And there was no tomorrow

He knew her by her step
Sometimes he'd say
Your feet, a stór, will dance
Across the sea

That blighted winter
Lying in the snow
He knew he felt her hands
Upon his hair

And heard her voice
Unaltered
O think will there be music
Over there?

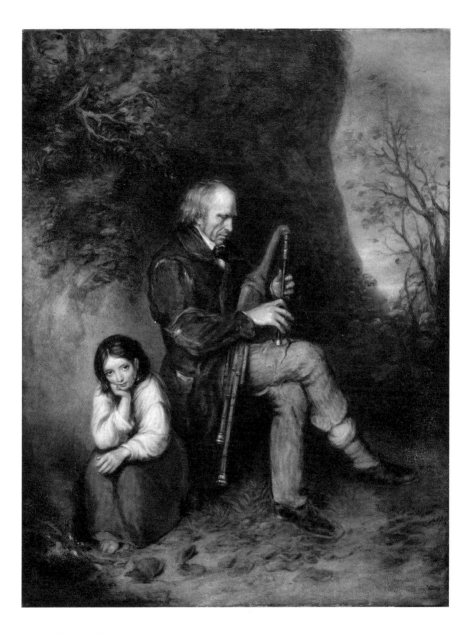

Joseph Patrick Haverty, 1794−1864
The Blind Piper, 1841
Oil on canvas, 76 × 59 cm

ENDA WYLEY

Lost Angels

The gargoyle falls
from the bell tower,
wind blows slates
from the roof

rain floods beams
over the sanctuary,
night fights its way
down the nave

and deep behind
St Mary's pipes
these angels
rolled in dust

and tied with
the spiders' thread –
so long forgotten
but suddenly found.

Unfurl what
you have lost –
see how they wake,
fly free, paler than swans

under Baggot Street Bridge
as they head for the Green
and the Liffey's flow,
then swoop over the cursed

Children of Lír that fall
in Parnell Square,
until at last they come to rest
in North Frederick Street

the moon a halo
about their heads
hung in the blue of night,
petals of fire, the thin stems

of time caught in their fingertips.
Open your studio door,
unfurl what you have lost –
hear your angels sing.

A group of decorative angels painted by Harry Clarke was discovered in
St Mary's Church, Haddington Road, Dublin and acquired by the National
Gallery of Ireland in 1968.

Harry Clarke, 1889–1931
Angels (detail), 1924
Mixed media, 193 × 86 cm

ACKNOWLEDGMENTS

Sincere thanks to all the writers who have so generously given their time, thoughts and words to the making of this book.

To my colleagues at the NGI and in particular Sean Rainbird, Lydia Furlong, Catherine Coughlan, Marie McFeely, Louise Morgan, Roy Hewson, Simone Mancini, Maria Canavan and former director Raymond Keaveney.

Thanks to the team at Thames & Hudson, especially Jamie Camplin, Julia MacKenzie, Susanna Ingram, Rowena Alsey and Rosie Keane who have given elegant shape to such a diverse collection of words and pictures. They have been a pleasure to work with.

Thanks to Nicola Freeman for planting the seed, to Niall MacMonagle for his advice and to Susie Kennelly for her assistance. A special thanks to Tom Farrelly for his insights and for listening.

CREDITS

INDEX